NOV 20 2012

Y0-BQS-352

3 1 68 00714 8787

Painting with a Lens

The Digital Photographer's
Guide to Designing
Artistic Images In-Camera

**Rod and
Robin Deutschmann**

AMHERST MEDIA, INC. ■ BUFFALO, NY

VERNON AREA PUBLIC LIBRARY
LINCOLNSHIRE, IL 60069

DEDICATION

We dedicate this book to that undying artist within us all, to those explorers of light who strive to create a world unique, expressing their vision of not just what *is*, but of what is possible.

Copyright © 2012 by Rod and Robin Deutschmann.
All photographs by the authors unless otherwise noted.
All rights reserved.

Published by:
Amherst Media, Inc.
P.O. Box 586
Buffalo, N.Y. 14226
Fax: 716-874-4508
www.AmherstMedia.com

Publisher: Craig Alesse
Senior Editor/Production Manager: Michelle Perkins
Assistant Editor: Barbara A. Lynch-Johnt
Editorial assistance provided by Chris Gallant, Sally Jarzab, and John S. Loder

ISBN-13: 978-1-60895-237-3
Library of Congress Control Number: 2011924259
Printed in Korea.
10 9 8 7 6 5 4 3 2 1

No part of this publication may be reproduced, stored, or transmitted in any form or by any means, electronic, mechanical, photocopied, recorded or otherwise, without prior written consent from the publisher.

Notice of Disclaimer: The information contained in this book is based on the author's experience and opinions. The author and publisher will not be held liable for the use or misuse of the information in this book.

Check out Amherst Media's blogs at: http://portrait-photographer.blogspot.com/
http://weddingphotographer-amherstmedia.blogspot.com/

CONTENTS

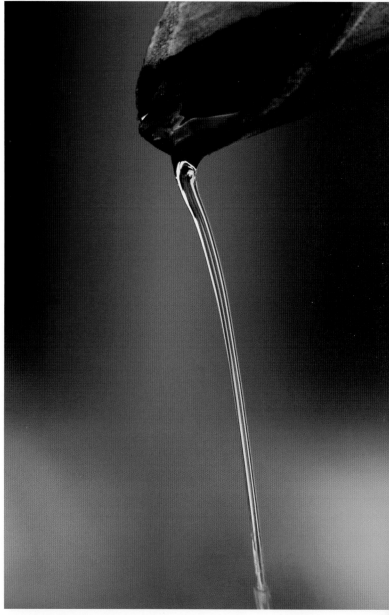

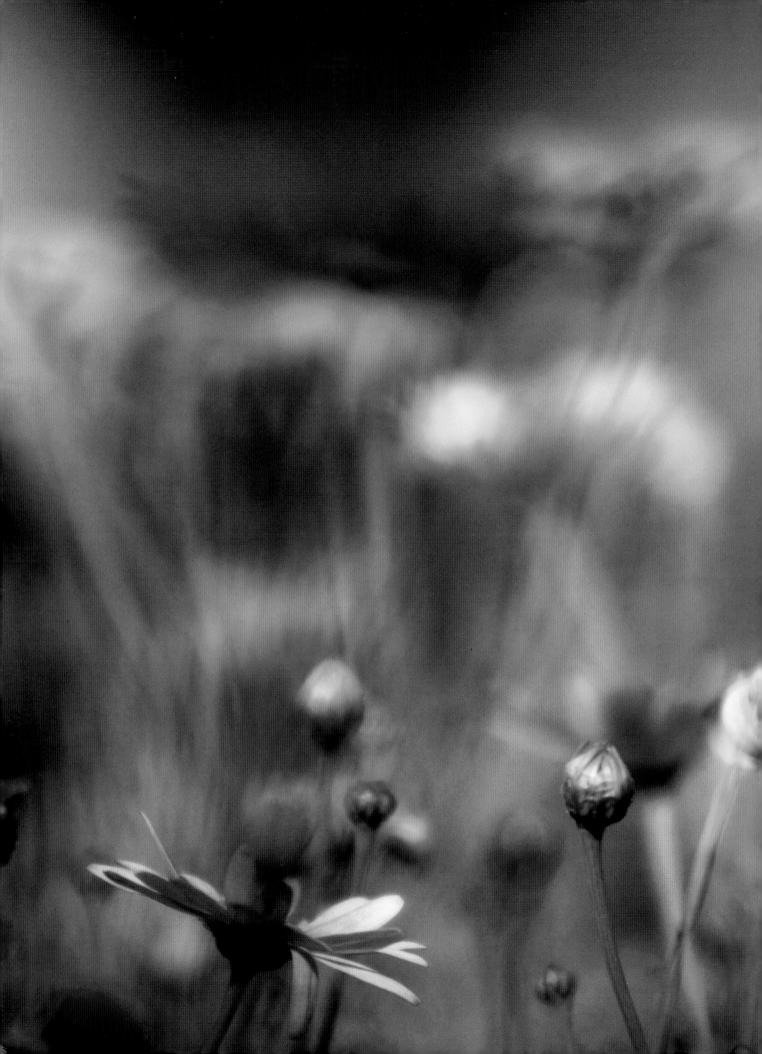

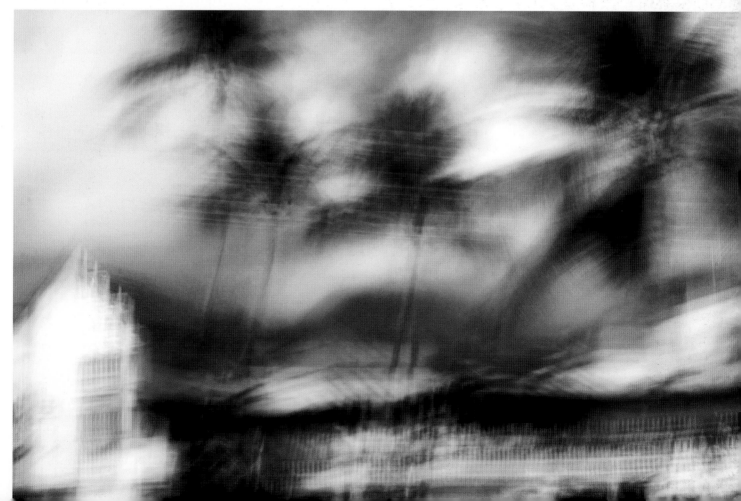

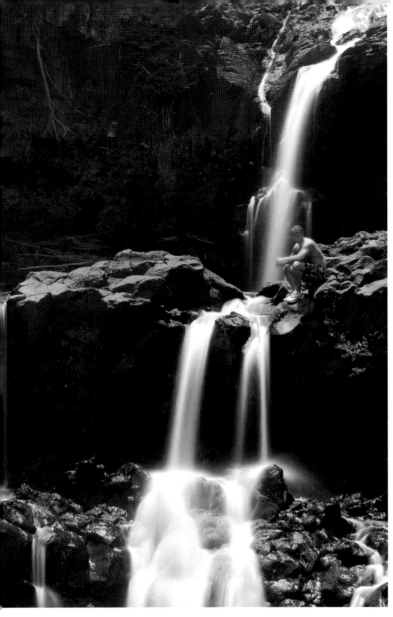

ABOUT THE AUTHORS

Rod and Robin have been teaching people to be artists with their cameras for years. Taking a practical approach to modern photography, the duo strips the nonsense from the facts and the hype from the truth. They believe that creativity lies in the artist's soul and not his camera bag. Touting the advantages of manual control, they offer a fresh view of photography that rebels against the norm. They strive to give each of their students the knowledge, will, and desire to wrestle back manual control over their camera and never look back. Their innovative approach and down-to-earth style have garnered them a loyal following of Southern California photographers. Rod cut his teeth in the graphic communications field as a young Marine Combat Correspondent, earning many accolades and awards. Both Rod and Robin are award-winning, fine-art photographers and award-winning newspaper editors. Together, they cofounded the In-Focus Learning Center in 2006 and have dedicated themselves to bringing art back to photography, one in-focus artist at a time.

ACKNOWLEDGMENTS

This journey has been amazing, and it wouldn't have been possible without the ever-positive support from our children, students, family, and friends. A heartfelt thank you also goes out to Craig, Michelle, Barbara, Kate, and the rest of our Amherst Media family who have supported our approach and given us a vehicle with which to reach millions of photographers looking for something different.

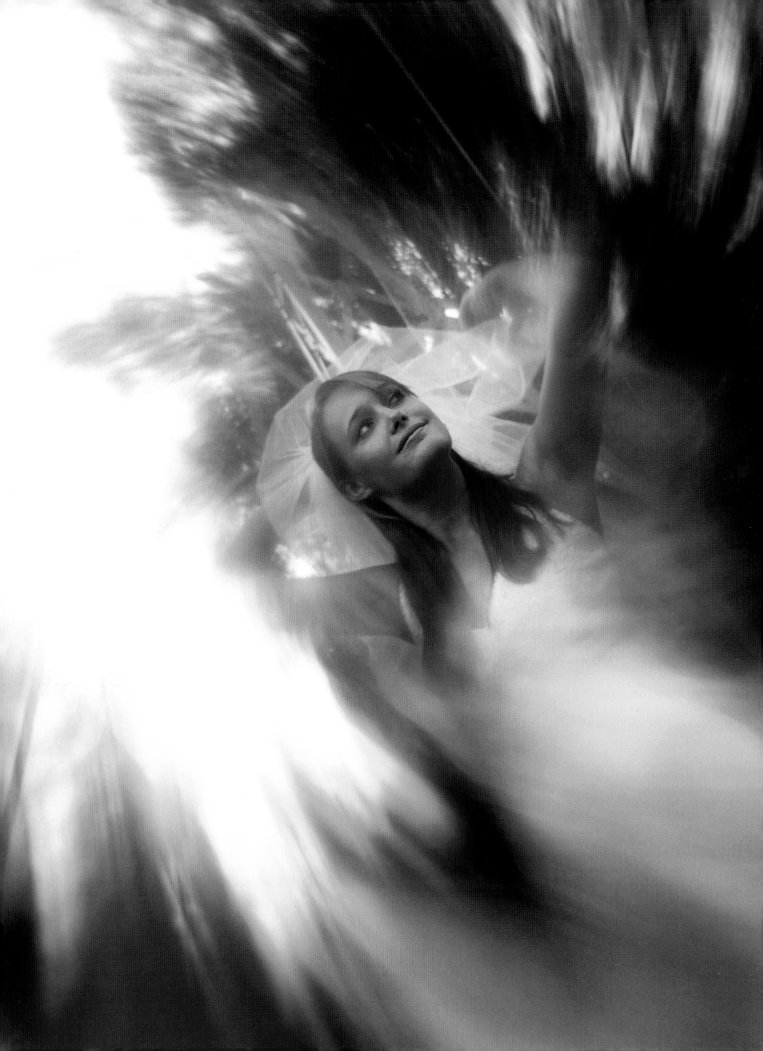

There is a different approach, you know. Photography doesn't just have to be about gear, shooting modes, and computer programs. It can be about expression, vision, and heart. It can be about the individual pride that comes from taking full control of the creative process and choosing all of the in-camera settings yourself. It can be about the art you create, not just the pictures you take. Photography can be about you.

WHAT IF?

What if we told you that you were wrong about photography? What if the majority of what you've read about capturing light was slightly skewed—designed to make you purchase equipment instead of making you an artist? What if we told you that more megapixels can't possibly make your bad photo better, only bigger? What if we told you that you didn't need your camera's meter, that you didn't have to hold your camera still, and that shooting in RAW was a bad thing for an artist? Would you listen?

What if we told you that all of the automatic modes in your camera are useless, that "fixing" an image in postproduction was pointless, and that it is your vision, not your equipment, that is holding you back? Would you care?

Now, what if we told you there was a different way, a way that sets free the visionary inside, a way that changes your perspective of the world and shows you options instead of rules? What if we told you that everyone can create art with their camera, and that it's more important to make sure that you are in focus than to ensure your images are? What if we told you that you were wrong about photography? Would you listen?

Facing page—You have a choice each time you pick up your camera. You can either record what sits in front of you or create something unique. Sometimes being creative can be as simple as rotating the camera when you shoot, knowing full well that if you used a slow shutter speed, the world would blur around your chosen axis, keeping the center area clean and in focus. Being artistic simply means you have allowed yourself the chance to explore and create, to take chances and express who you really are. **Right**—An artist can use photography to express himself, to share an idea, to challenge society. It doesn't just have to be about portraits, weddings, and poses. A camera is an amazing tool. It can truly release the artist inside of us, if we let it. You have a decision to make when using a camera. You can either create an image that reflects who you are and how you feel, or you can take a photograph of all the stuff around you. The choice is yours. We teach our students how to see beyond one simple subject and put an entire graphic puzzle together. We search out the fantastic by visualizing how things *could* look.

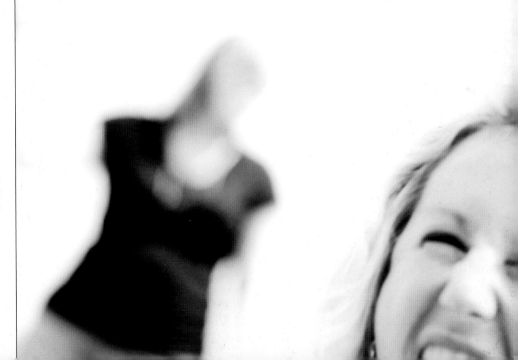

ABOUT THIS BOOK

Digital photography is evolving. Demands are changing. People aren't buying the hype anymore. They know more megapixels won't make their bad photos better. They realize that they can't "Photoshop-in" creativity or pride. Millions of people are discovering that their equipment just can't give them what they truly want. They are looking for guidance, but all they are getting is hype.

Lower prices, do-everything lenses, and marketing campaigns that promised the moon convinced many that the dSLR held the answers to their picture-taking woes. They were looking for magic, but what they found was the truth: great photographs don't come from great cameras, they come from great people. No matter how much you spend on your camera, it can only capture light, it can't create art. And herein lies the real problem: there are very few books that teach people to be artists with their camera, that start from the very beginning and push to the end. There are plenty of books on the market that show readers how to use their cameras and introduce them to auto features and shooting modes, but they don't teach them how to be visionaries, to think beyond what they see, to use the physics of light to their advantage, to create messages instead of just taking pictures. And not one book shows its readers how to combine the mechanics of photography with their own unique ability to visualize a message, to see outside of the box. We decided to change that.

Painting with a Lens explores real vision—of what we see and what could be. It explores the truth and challenges its readers to let go of societal pre-

Below—This is not a book on photography. It's a book on how to use photography to create art. A camera simply captures light. It's up to its owner to make something special with it. Something as simple as not focusing on a person (as in the photo below) is but one way to create drama, add interest, and express yourself. Here, the focus point was simply shifted from the obvious subject (the person) to the not-so-obvious subject (the flower). A new and endearing image quickly came into focus. With this one simple, out-of-the-box decision, the photographer stepped from his comfort zone, away from what others would consider normal, and took a giant leap toward becoming a real artist with his camera. Sometimes the emotion and feeling of a scene does not require crisp focus on the usual (or normal) subject matter, just a deep understanding of the message itself.

Right—Before using any of the techniques outlined in this book, you'll need to turn off every auto setting in your camera. You'll be asked to ignore the camera's internal metering system and choose the amount of light that is best for the feeling you want to impart in your image. You'll be asked to take control of everything from white balance, to contrast, to saturation levels, and even to make hue adjustments on the spot—before you shoot the picture. This book isn't about auto features or fixing things in postproduction. Painting with a Lens is about vision, passion, and mechanical know-how during the creation process.

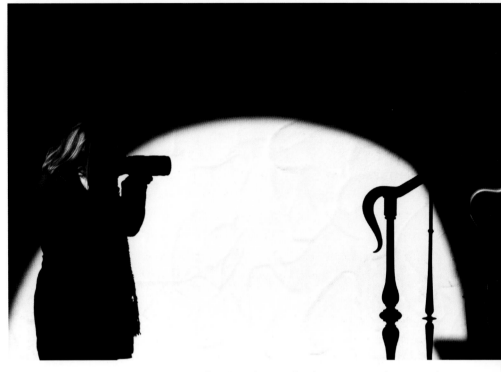

■ *Painting with a Lens* is as much a philosophy as a collection of techniques. It's a way of thinking, a way of creating. It offers something different. It explores the differences between simple photographs and heartfelt messages, between true "expressionism" with a camera and simple documentation. Its approach is unique, and its philosophy marks the next stage in the evolution of digital photography—that of creating art rather than simply taking photographs.

conceptions, marketing hype, and falsehoods. It asks them to search out real meaning in their images. It makes the bold assertion that people really do care about what their images say and how they are interpreted.

As you may have noticed, most photography books are written with the assumption that readers want to be professional portrait, event, or wedding photographers. This book challenges that belief. It zeros in on readers who want to use their cameras for something else. It reaches out to the artist in each of us. It pushes readers to think outside of their own understanding. With this book, we wanted to give the art part of photography its due recognition, to show people of all skill levels how their cameras can free their vision, how it's not just about gear, editing software, and a blind adherence to auto features.

This book offers a practical approach to modern photography. It shows photographers that they have choices and that the secret of great images lies in the heart of the artist, not in the gear. It gives its readers the knowledge, tools, and confidence to practice, fail, and learn from their mistakes. It explains the physics and mechanics needed but, more importantly, encourages its readers to try something different with their cameras and create art. Art with a camera is real. It just takes an entirely different approach to produce it.

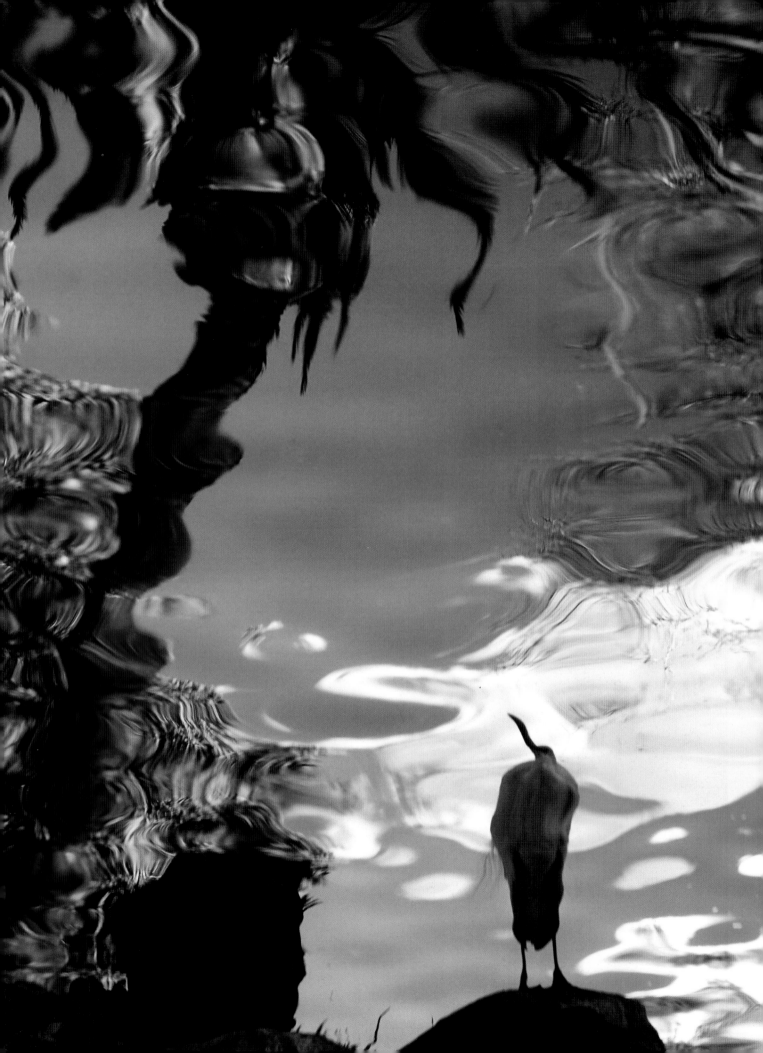

1. LEARNING TO PAINT

There is no shortcut to creativity. There are no auto modes on your camera that give you artistic control. You can't want to be an artist yet not want manual control of your camera. You need one to accomplish the other. You have to make a choice in the beginning of this journey. Do you want to be an artist with your camera, or do you just want to take pretty pictures?

AN OVERVIEW

There are only two things a person can do with a camera in hand: record and create. Most people choose to record what's in front of them, documenting the way something looks instead of sharing with others how it makes them feel. Ironically, these same photographers emulate, revere, and idolize those artists who choose to create instead. They buy the same gear and use the same computer programs, hoping that some day they too can "take" the same type of photographs. The intention is noble, but the plan is flawed. Artists take risks, not just pictures. Their messages have no more to do with what type camera they use than the color of the socks they wear. Success doesn't come from blind imitation. It is born in the heart, nurtured by the spirit, and grows from a willingness to create something unique. The truth (as all of us,

Facing page—Sometimes, creating art is as easy as looking beyond "normal." Here, the photographer ignored reality and focused his lens on life's reflection in the water. Art truly is in the eye of the beholder— it's just that sometimes all the stuff in front of us gets in the way. **Below**—Creating an intentional blur, such as the one illustrated here, is a gamble. Society expects an image to be in focus. Straying from that path by using extremely shallow depths of field or, as was the case in this image, a multiple exposure is dangerous. Artists must make a choice when they create an image. Do they take the expected route or run the risk of condemnation and produce an image that more resembles who they are and how they feel?

honestly, already know) is that artists don't just take pictures of things, they communicate a feeling. They share a little piece of themselves with the world and aren't afraid of the criticism that may follow.

WHAT'S VITAL

Vision is key. You must see something in your mind's eye before you shoot it. You must imagine the possibilities because you understand the options, then just go for it. This is not the same thing as pointing your camera at something and taking a pretty picture. The goals of a typical photographer are quite different from those of an artist, and their approaches differ dramatically. An artist uses his understanding of his equipment to capture an image that shows the world in a new way, not the way that it appears at first glance. He visualizes a possibility then creates a unique image. He exploits his experience, not just his equipment. He uses what he knows, what he expects. He sees what others can't or won't.

A PAINTED APPROACH

A blank canvas, some paints, and a brush—nothing is as intimidating or as freeing. Limitless possibilities sit in front of the artist. There is an unending canvas of creativity just waiting for his hand, ideas, and message. While this proves intimidating to most, a painter simply smiles. He begins with his background, visualizing an end result and then builds his way up, adding layer upon layer of colors, tones, shapes, and patterns until what he saw in his mind's eye comes to fruition.

It's a difficult process, and mastering it will take time, but the results can be spectacular. Artists challenge society; they push their vision past the obvious and take us on that journey with them. Painters make us hold our breath. They lead us to another reality splashed with colors, textures, and tones drawn from their imagination, using tools we all can wield.

The question for photographers is, What if we were to take a more artistic approach to our own image-making process? What if we applied the same artistic "painting" style with our tools? What if, instead of starting with our subjects, we began with the background and slowly added graphic elements with intent and purpose? What would happen?

Most photographers (admittedly) sketch with their cameras. They worry about their subject first and allow the other pieces to lie where they are—eliminating, blurring, or masking them later in a computer. But what if we took a more proactive approach? Wouldn't the image itself seem more controlled, a bit more polished? What happens to our own vision once we see what is truly possible? How far can we grow as artists if we give up the pursuit of just being a photographer? Great photography is truly about possibilities, not just subjects or gear.

■ It's an artist's job to stand up to average and speak for the individual. Artists push us forward as a species, set the pace, and make life wonderful. Without artists, we would all stagnate.

Right—It's not about what paints you have, it's how you use them. We in-focus artists take a different route than most when we use our cameras. Ours is a truly painted vision. We begin with our background (like any good artist), making it the best it can be with whatever tools we have. We then slowly add graphic element after element until a real piece of art emerges, something that can only be visualized by a person who sees beyond what's in front of him. We let the world of lines, shapes, patterns, colors, and tones fall over us like a blanket, allowing us to look beyond "normal" vision and see what is really there.

■ It's amazing what can happen when you stop seeing just one thing and start concentrating on a real graphic message, when you give up on the idea of *fixing* an image later and just start shooting it right the first time.

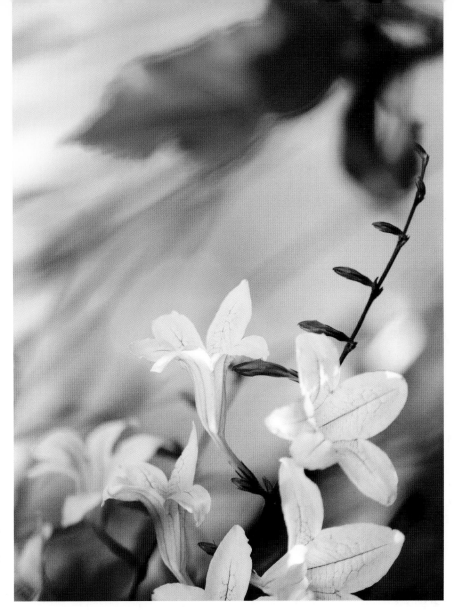

A Walk-Through. We take photographs of the things in the world that entice us. We sometimes like to think it's our gear that makes it possible, but it comes from the heart. Take, for instance, a simple image of flamingoes—something anyone with any camera could capture. There is nothing wrong with the image. It is what it is—a simple representation of what was before the photographer. It's hard to pass by without taking a photo; it's not called a "flamboyance" of flamingoes for nothing. But what if we approached the scene differently and took an artistic approach? What if we used the patterns the flamingoes create and their color—the things that drew us in? What if we built an image using the flamingoes as our background instead of our subject? What if our *message,* not just the stuff we shot, was flamboyant?

It's not about shooting a simple picture of what's in front of you, it's about creating a dramatic illustration of how this stuff makes you feel. You can express yourself with your camera. You can see beyond your own vision, but it will take willpower to make it happen.

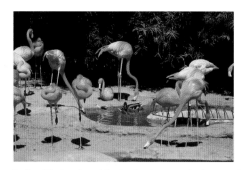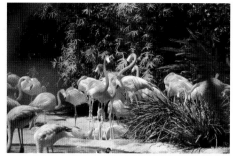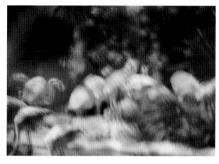

Left—We begin with the background, the single most overlooked graphic element in photography. The background is the root system from which everything else grows. **Center**—Here, we've changed shooting positions and placed a few graphic elements (weeds, twigs, and flowers) in front of the flamingoes. The shallow depth of field blurs these elements, making them unrecognizable. **Right**—In this shot, you can see a bit of spatial distortion occurring as we move our focus point closer to the lens. The magic starts to show when we "give up" our subject.

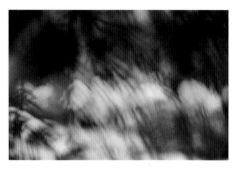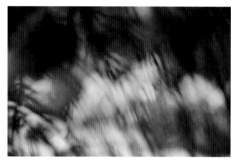

Left—As we push the focus point even farther from the flamingos, the spatial distortion intensifies. The image is starting to look like a painting. **Center**—Even the slightest change of focus position or subject location alters the look of the lens aberrations, making the paint strokes appear elongated and introducing a more dramatic rhythm to the image. **Right**—As we move our focus point farther from the flamingoes, the identity of the next tier of graphic information comes into focus.

Left—Here, the focus point has shifted to a closer tier of graphic information (a plant). Notice how the pink flamingoes are no longer flamingoes—they're just shapes and colors. There is yet another graphic tier beginning to show itself in the left-hand side of the image—the white blur. **Center**—Pulling the focus point back toward the white blur reveals additional shapes and more tiers of graphic information. Note that the spatial distortions (the paint strokes) begin again with the green weeds. **Right**—Moving the focus point closer to the camera shows the outline of even more useful shapes. The green weeds are combining with the flamingoes to create a beautiful painted background.

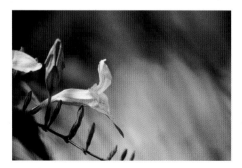

Left—Moving the focus point a bit farther back reveals the flower itself. Combined with our new (and utterly amazing) painted background (composed of bright green weeds and colorful pink flamingoes), we achieve an image that no one can see, let alone take a picture of. **Center**—This is what the scene looked like to the naked eye. Very few people would have lined up the six graphic tiers of information to create the image. They would have had to give up on the obvious subjects in front of them (the flamingoes) and would have had to know that when compressed (blurred) background and foreground elements are united, they can create some spectacular effects. **Right**—Change positions and you can create a new reality. Here, we moved slightly and the flamingoes moved greatly. We again started with our background "color."

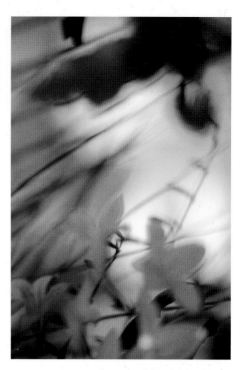

Left—We begin by refocusing the lens (moving the focus point closer to the camera), and the painted strokes begin to appear. **Center**—Since the background will simply be a painted tapestry of color, why not rotate the image 90 degrees after we take the shot? After all, we are no longer shooting flamingoes, so the eventual orientation of the image doesn't matter. **Right**—Moving the focus point back a little farther reveals the flowers. Note that this time, they appear dark. This can easily be remedied with the addition of light from an off-camera flash.

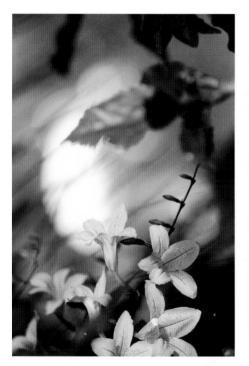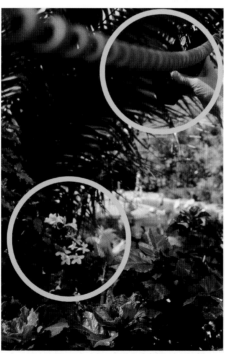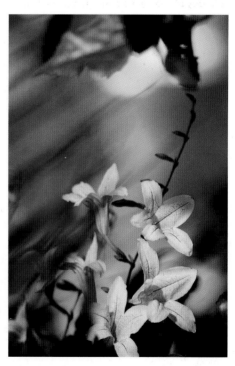

Left—With the extra light from the flash, the focus becomes rock solid and the separation between graphic elements becomes even more apparent. The image is really beginning to take flight. **Center**—Here again is how the scene appeared. The flash has been introduced to add needed light. Positioned off-camera, the flash produces flattering and natural-looking shadows. It is simply handheld and pointed at the flowers (the power settings and angle of coverage settings were adjusted to taste). **Right**—To create this image, we set high contrast and saturation settings in the camera. Compare this image to the first one in the series, which was made with low contrast and saturation settings. The first image appears more passive. Remember, as an artist, you can dial in how something makes you feel. Photography is not just about how something looks.

The Peacock Effect. The flamingoes in the previous example would be a tough subject for most photographers to move past. We've been conditioned as a society to see and then photograph bright, colorful subjects. Robin has a name for this universal preoccupation with startling objects: she calls it the "peacock effect." Like a moth to a flame, we zero-in on what we think our subjects should be, ignoring the other possibilities around us.

This explains, in part, why the majority of photographers today chase lenses and camera bodies. They need to get the best-possible photo of that peacock and will do anything to make it happen. When their quest fails (as it often does), they resort to "fixing" their image in the computer—adjusting its color, saturation, and white balance to make it look more creative. The sad part is, that's not being creative at all. Manipulation is not art (it's not even real photography). Creativity happens at the moment of creation. It's the result of moving beyond what society sees and expects—it's not the result of taking a lackluster image and pumping it up in your computer.

Robin offers a solution that will help you move past the peacock shot: "Take the peacock picture first," she says. "Get it out of your system. Then look closely at what the peacock is made of. If its colors and shapes would make a great blurred background, then blur them and use them that way. Use your longer lenses and compress that blur. Get closer to your foreground elements and use a larger aperture to further intensify the blur. Then move forward and backward slightly and use the power of perspective to make that blur whatever size you want it to be. Work hard and concentrate on your new vision. Start seeing your 'subjects' as backgrounds, then find something to put in front of it. I promise your world and your view of photography will change forever."

That's good stuff!

■ Fight the peacock effect. Creativity (real art with a camera) has little to do with pretty subjects; it's about the techniques you use to show the world how those pretty subjects make you feel. There is a way to be creative with your camera, and the process begins in your mind, not with your camera bag.

THE REAL ISSUE

The number of real artists with cameras is dwindling. Our dependence (as a society) on auto settings and downright fear of manual control see to this. Worse yet is the fact that the better auto features become, the less reason we have to push our skill level and vision. The less we push, the less we think and understand. The basics are being forgotten and, once gone, true expression with a camera will die. This is why we must take a stand. We must show the world that there is another option, another reason to use the camera. Artists have voices. It's time we used them.

TOUGH LOVE

Think for a moment about what we tell our kids. We ask them to play with their guitar, to play the piano, to play with their crayons, hoping that one day they'll appreciate the tool and become an artist with it. Yet, what are the first

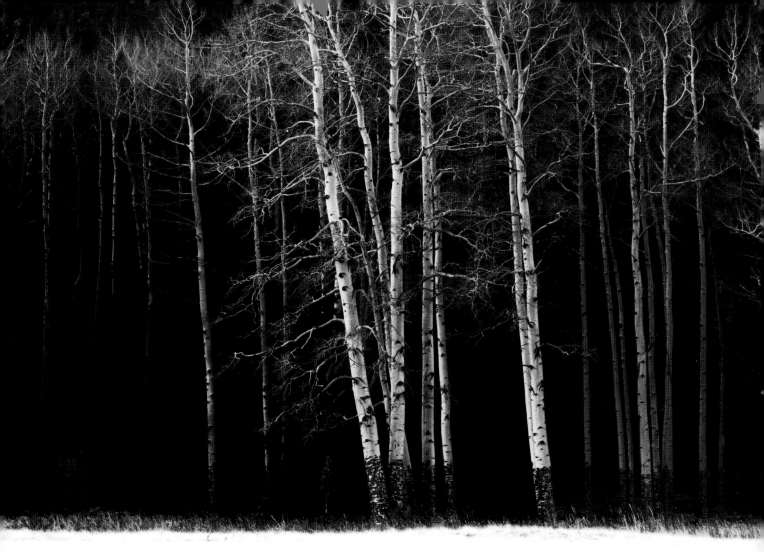

Above—While photography today isn't complicated, learning to do something well with our cameras is. Real photography—true expressionism with a camera—isn't about just one thing, it's many things to many people. It's as much about inner reflection as it is about a portrait session, a wedding gig, an office party, or even a paycheck. Although many photographers rely on and tout the use of auto systems, some of us enjoy the challenge of doing things ourselves. We don't need to make every image perfect. We revel in the pride that comes from heartfelt workmanship, of knowing what to expect when we use certain settings and using that knowledge to create something special. The above image is a wonderful example of this. It appears the way it does because the photographer knew how and why to choose various internal camera settings. It was envisioned first, and then shot in camera, in monochrome. The simple fact is, the image was shot because of how it would look in black & white. It wasn't an afterthought; it was the only reason the photographer pulled off to the side of the road. If you are not inspired by what could be, then, believe us, you won't take the picture. And, the last time we checked, it's really hard to "fix" or modify an image if you never shot it in the first place.

words out of our mouths when it comes to photography? "Don't play with that camera, it's not a toy." We have put the camera and its associated gear on a pedestal, forgetting that it's just a box with a hole in it—a rather impressive calculator that just happens to capture light.

Worse yet, after more than twenty-five years of autofocus and autoexposure, most people have forgotten the basics of photography. They have forgotten what it means to create, express, and take on a challenge. They strive for acceptance, anonymity, and normalcy, hoping to simply take an average picture. Few take the risks necessary to grow.

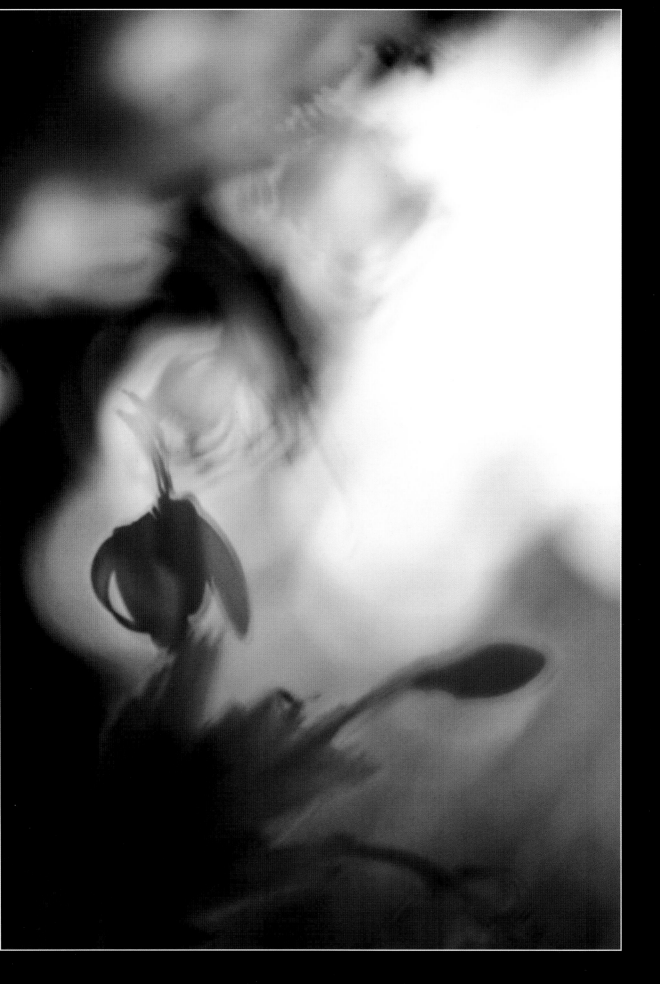

Facing page—Letting go of societal norms is tough for many. Taking a blurry photo such as this one may not seem right, but this type of image (an abstract) is a valid choice for an artist—and it's one that shouldn't be overlooked. If you were to shoot just like everyone else, getting the same light, the same focus, the same color, where would that leave creativity or individual pride?

Our goals have softened as much as our resolve. Today, it's all about "fixing" images after the fact, trying to make other people like them, hoping to attain the glazed-over ideal of a perfect image. Editing programs are touted more than individual skill. Depth of field control is as foreign to most new photographers as composition. How can all of this be right? What does it do to our view of photography, and where does it lead us? Some actually think that the auto modes on a camera can help them be more creative, that they can alleviate the "burden" of having to choose the amount of light they capture or what will be in focus. This is just wrong. If those things weren't that important, then why do so many professionals spend countless hours fixing them after the fact? Those creative options make up the heart and soul of every message we create. An artist can't give up control over those options. We need to stop being afraid of making mistakes and use them to gain experience. We have to have faith in ourselves and what we're capable of. We can all do this. We can bring real art back to photography, but we've got a long road ahead.

A TELLING QUESTION

If you were to hire a photographer and a musician for the evening (let's say for a wedding), you would probably do a bit of research first, listen to online samples, check out galleries, ask for references, and (hopefully) hire the best, right? Now, let's say both show up at the event. The musician opens up his case and pulls out a child's guitar with two buttons—one labeled jazz, the other rock. He stands there, smiles, and starts playing. Would that upset you?

Below—You don't see the guitar player complaining that it's too hard to play certain notes and that his clients should give him a pass and not worry about it. If he's not comfortable with a live performance, if he doesn't think he's ready, then he doesn't do it. A skilled musician treats his art with respect. He dedicates himself to it.

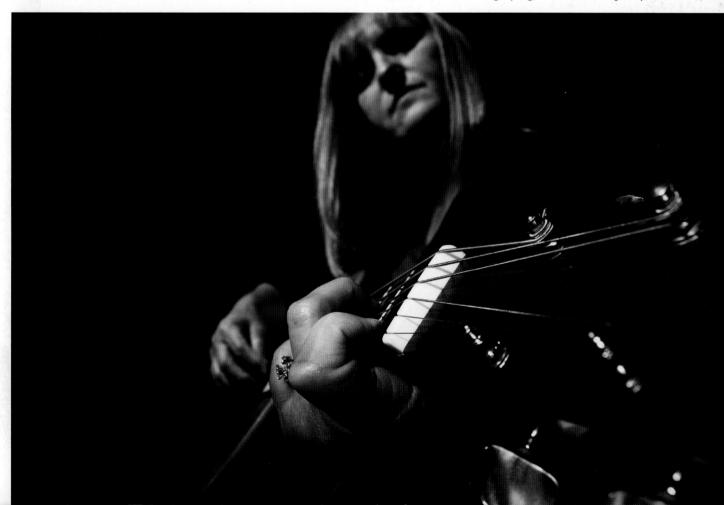

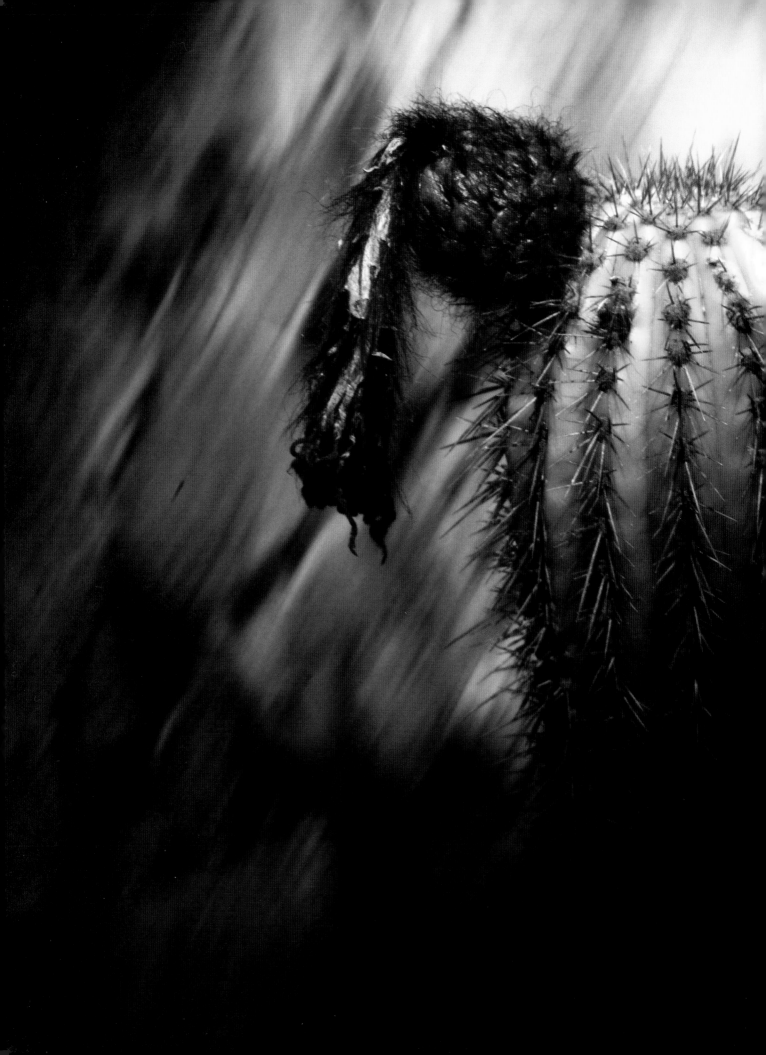

Facing page—There are thousands of visual possibilities and options that surround you each and every day. The world can and will look different than it appears before you now. An artist challenges himself to not only be aware of these alternate realities but to learn the physics and mechanics needed to capture/create them. He pushes himself to the next level by learning and understanding not just the basic compositional elements that make up every image but also how and why people react to certain visual stimuli. In turn, he uses that information to make his message even more pronounced. While the in-camera "painting" technique used to create this image was fairly simple (the swipe, described in chapter 6), the reasoning behind its use was a bit more complex. Rhythm is a huge piece of the graphic puzzle. It's something the mind wants to see, as it helps with closure and creates a very loose type of balance. A painting technique was used to create this image, which depicts this type of rhythm. It's not just about a flower or a technique. It's about the meaning and purpose of art.

Of course it would. You hired an artist, someone whom you expect to be in something other than auto mode. Yet would you (even for a second) check to see if your photographer were shooting in auto? No, you wouldn't. And if he was, would it bother you? No, probably not.

On some gut level, we have given up our reverence for art with a camera. It's no longer about the artist and what he's capable of, it's just about the pictures he takes. It's not about his ability to express or create. We just want someone with better equipment than we have to shoot the wedding. And what of the "professionals" who follow suit? They no longer push themselves. For them, it's a job. They have a list of shots to capture, and since no one is asking for the "good" stuff, they don't bother to create them. They take the simple shots, fix them in postproduction, and collect the check.

What kind of example is this? What does this mean to our children, to the next generation of photographers? A musician doesn't show up at a venue, play his guitar in a vacant room, edit his music on a computer, then come out and play the recording only when he thinks it's perfect. He does it live. He has pride. Sure, he makes some mistakes, but his art shines through. He has experience. He uses his failures to firm his resolve. He has skill and he's paid the price to garner it: hours upon hours of practice each day until his fingers bled. Can you, as a photographer, say the same thing? Have you put in the same amount of effort? Can you honestly say that you've developed the callouses a guitar player has, that you've learned to stretch your fingers as he, until you know for a fact what will come out of your camera before you take the shot? Seriously, would you call a guitar player who uses auto modes a musician, or would you call him a cheat? Be careful of your answer, it will define you.

The Opposition. Many professionals today would argue that it's impossible to be *that* good, to dial in all those settings while shooting an event such as this, that they have other (more important) things to worry about. We disagree. Practice makes perfect, and there is nothing more important to a photographer than capturing the perfect amount of light, of being creative or speaking from your heart. The real point is that you're losing your creative edge by shooting in auto mode. If you give up on developing and perfecting real skill, then you give up on any chance of growth. If you're not in charge of the options your camera affords, then you'll lose sight of them. You won't know what can truly happen. You won't have a clue.

If that didn't sell you on the idea, how about this? True artists are commissioned. Photographers are hired. Who do you think gets paid more, a disc jockey who simply plays songs from an iPod or a musician or band? An artist is brought in because of his own unique vision and because of what he can produce—the art that comes from his soul. A photographer is there to shoot things. Sure, the world needs both, but who do you think is going to

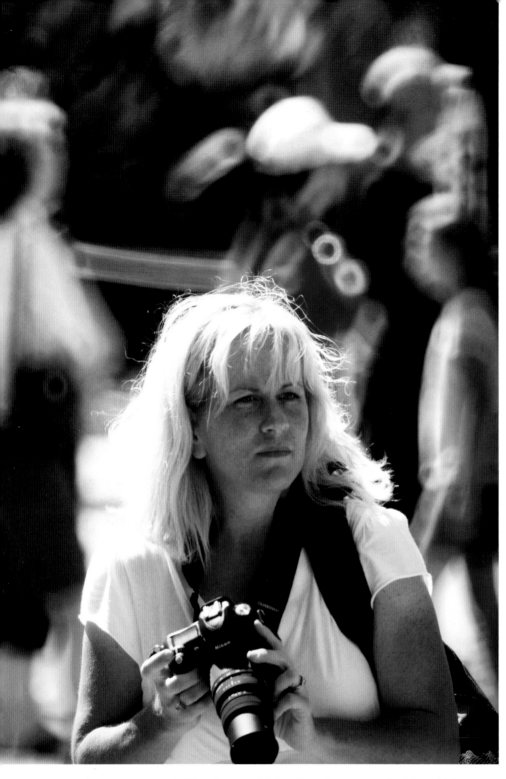

make more money? Who do you think will make a name for himself, be more respected, be more in demand? And who will change the world itself, setting the example and leading others to real art?

WHAT IT TAKES

To do this well, to become an artist with a camera, you will need to return to some traditional values, such as hard work, dedication, and a willingness to

learn from your mistakes. You have to begin to see the world as a set of options instead of subjects, to see possibilities instead of mountains, to see light instead of people. And, as you'll soon learn, this has very little to do with the equipment you use. It's an inward journey that allows you to explore who you are and how you see the world. The camera just captures that vision, nothing more.

Difficult? Yes. Impossible? No, not by a long shot.

UPCOMING CHALLENGES

Each person is challenged by full manual control and artistic visualization in a different way. Many struggle with the technical side, while others find the abandonment of their own preconceived notions intolerable. No matter your challenge, make it a point of pride to keep moving forward. Make a commitment to yourself to realize your creative goals.

Here are some important and attainable goals to keep in mind as you undertake this journey:

- Keep your goals simple at first. Start with the simple techniques and work your way up. Be sure that you understand the approach before you pick up your camera.
- Keep an eye out for your background and try to be as creative with it as you can. Think about how the graphic elements align within your frame, and visualize what would happen if you were to blur that background, to make it bigger or to hide it. Think before you shoot. Move with purpose and design with intent.
- Don't delete anything! Your images reflect your growth as an artist. Study the shots that failed and take the time to learn from your mistakes. Remember, you have to learn to sketch before you paint, you must know chords before you can play a guitar, and you must learn how to chisel before you touch your first piece of granite. You need to know how to use your tools before you can master your art.
- To be an artist with a camera, you must be able to use your camera in manual mode. You will need to know how to control blur, change your camera's internal settings, adjust the aperture and shutter speed, and more. Get to the point where you are comfortable with having full manual control, and then get ready for the ride of your life.

SOME USEFUL GEAR

While true art with a camera can be accomplished with any gear, there are few pieces that will prove useful as you learn the techniques.

Lens Recommendations. Often the power of compression will play a key role in your ability to blur foreground and background elements. Many of

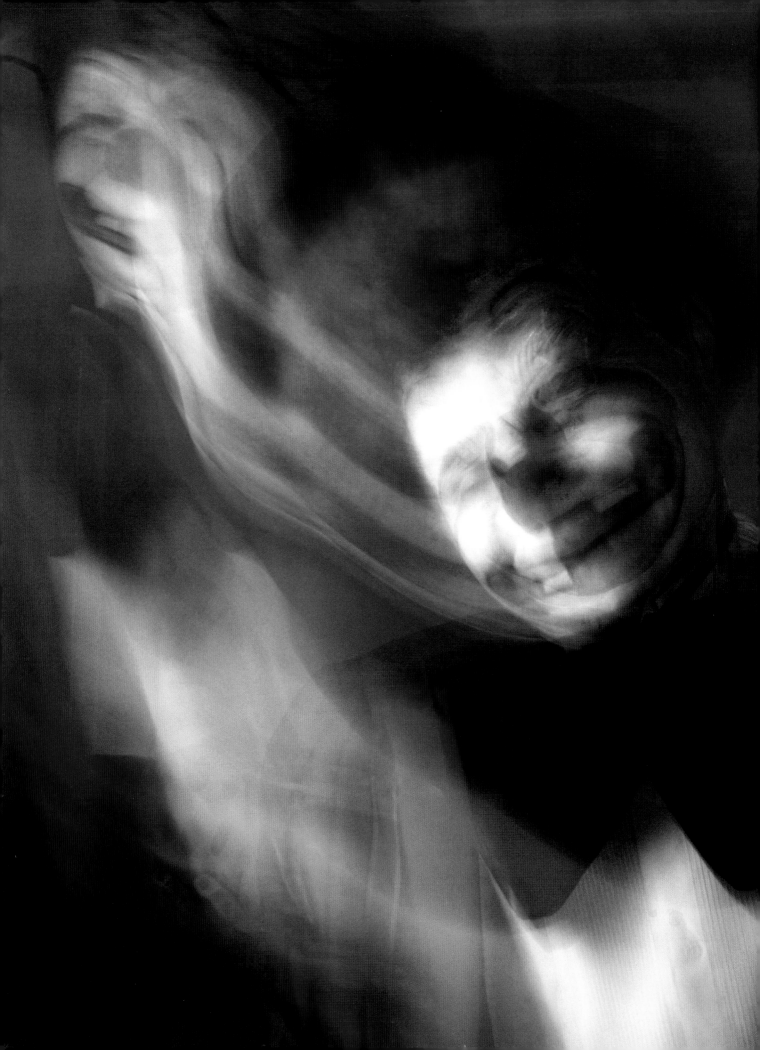

Facing page—Photography is truly about expression. We can use the tool to share our innermost thoughts. When I was young, I was deathly afraid of clowns. Although this fear has subsided with age (thank goodness), I can still explore this memory and these feelings with my camera and flash. In this image, we've connected the dots between the artist I am today and the child I was then.

the techniques in this book require that type of control. Longer focal length lenses (anything between 85mm and 200mm) will help you attain shallow depth of field. Lenses that afford larger aperture settings (such as f/1.8 and f/2.8) will also prove useful, though they are not required. Good painted images can be created with any lens, but some make it easier than others.

Filter Options. When painting with a lens, you'll often want to cut the amount of ambient light. Slower shutter speed techniques such as the flutter and swipe require it (these techniques are addressed in chapter 6). To that end, you'll need a few pieces of extra gear. Neutral density filters have long been a photographer's best friend when it comes to cutting ambient light. These can get expensive and require quite a bit of space in your camera bag. A variable neutral density filter is a perfect solution. When the filter is rotated, the photographer can dial-in the exact amount of darkness he wants to add to his image. This is a very expensive option. Fortunately, there is a more economical and classic alternative: by simply "crossing" two linear polarizers you can mimic the same effect. To do this, place one linear polarizer on top of another on your lens. Rotate the bottom polarizer to eliminate glare and turn the top filter to eliminate ambient light. Voilà—instant variable neutral density filter. (Note that circular polarizers cannot be crossed.)

Not all linear polarizers are made the same. Some have a creative "breaking point"; depending on the manufacturer, you may find that crossing polarizers does little more than put a shadow across your image. Some brands work only at 80 percent, while others give it their all. Some allow you to strip every bit of ambient light without consequence, while others create a drastic shift in color. If you already own a few linear polarizers, test them out. Take some slow-shutter-speed images and see what happens. If your current gear isn't up to task, it may be time to consider a few more accessories.

PROVEN INSPIRATION

We make it a point to highlight new artistic techniques, showing how anyone with any lens can create art with their camera. To see more of this style of photography or pick up a few artistic insights, please follow us (and our students) on Facebook at www.facebook.com/iflcsandiego or visit our web site at www.iflcsandiego.com.

A MANUAL APPROACH: THE NITTY GRITTY

To get the most from your camera and grow as an artist, you must be in full manual control of your equipment. There is no getting around this. This option can, admittedly, be tough on the new photographer, as the images produced will always reflect his level of experience. If he hasn't learned to control a shutter, adjust an aperture, or change his contrast and saturation in-camera, his pictures will show it.

Proficiency in manual mode requires perseverance more than anything else. The artist will have to deal with the mechanics of the camera, the physics of light, and the psychology of composition all at once. You'll encounter dark photos, blurry photos, blown-out highlights, and colors that look "off." Remember, with each failure comes a chance at redemption, with each mistake, a chance to learn.

Imagine you've been playing a player piano your whole life and now, you've unplugged it. Sure, you know where the keys are, but you really have no idea what to do with them. Similarly, you can't expect instant success when going full manual with your camera. It's going to hurt at first. With time and experience, however, things will change. Each practice session will make you better and help you develop your vision. Before long, you'll be able to play. Before long, you'll be creating your own music instead of just buying new songs from the "real" artists.

HOW IT ALL WORKS

Believe it or not, you already know nearly everything you need to know about basic manual digital photography. It's just like filling a glass with water. You have a vessel that needs to be filled (in our cameras, this would be the image sensor). You have a faucet "knob" that needs to be turned (the aperture in our cameras), and you have the amount of time required to fill the cup (in our cameras, this is the shutter speed). Each choice—whether it be the size of the cup, the size of the opening in faucet, or how long you allow the water to run—will affect how much water you end up capturing.

THE SHUTTER SPEED

The camera's shutter is in front of the image sensor and behind the lens's aperture. It is usually made of two metal (or plastic) blades, sometimes called

> ■ Becoming an artist means knowing what your most basic options are. In photography, nothing is more basic than understanding the effects of your aperture, shutter speed, and ISO selection.

Facing page—Being creative means being comfortable with your gear. Spend as much time as needed on the basics. Learn to control depth of field, exposure, and glare. Discover the action-freezing power of fast shutter speeds and the creative power of slower ones. Join a photo club, enlist the aid of family or friends—do whatever it takes to garner the experience you need to become an artist with a camera.

curtains. When the shutter button is depressed, the first blade/curtain opens and the second follows, allowing a certain amount of light to enter the camera. The amount of light is dictated by the length of time the shutter stays open. An artist chooses this shutter speed to illuminate the subject and scene, create mood, or control motion blur.

Most digital single lens reflex (SLR) cameras can shoot at shutter speeds between 30 seconds and $\frac{1}{4000}$ or $\frac{1}{8000}$ second. Artists can also take advantage of the "bulb" setting their camera offers. Shooting on "bulb" allows for even slower shutter speeds—several minutes or longer. (Chapter 6 details some beautiful painterly effects that can be created when shooting using the bulb setting.)

When you reduce your shutter speed one "click" (e.g., from $\frac{1}{60}$ to $\frac{1}{30}$ second), the amount of light that strikes the image sensor is doubled. When you increase your shutter speed by one "click" (e.g., from $\frac{1}{30}$ to $\frac{1}{60}$), the amount of light striking the sensor is reduced by one half.

An Experiment. Let's conduct a simple experiment that will help you understand how adjusting your shutter speed will allow you to get just the right amount of light in your image, which can help your develop the desired mood in your image.

What you need:

- Lens (any lens will do)
- Your camera should be in full manual mode.
- Your lens should be set to manual focus.
- Adjust your aperture until it reads f/5.6.
- Adjust your camera's ISO setting to its lowest numbered setting, either 100 or 200.

How to Do It. Rotate the shutter speed dial until it reaches its fastest setting (e.g., $\frac{1}{4000}$ or $\frac{1}{8000}$). Point your camera at something, focus your lens, and shoot. Look at your photo on the LCD. The image will be dark, if not black.

■ Controlling your image means knowing where the knobs and dials are—specifically the ones that control the ISO, aperture, and shutter speed. If you are not familiar with their location, read your camera's user manual. Don't stress, though. You only need to know where these controls are and how to move them right now.

Left—A quick shutter speed can freeze even the fastest-moving subjects.

Right—An artist uses his shutter speed for many things, the most important being the creation of mood. Mood is what happens when the light itself becomes important. Adjusting your shutter speed and shoving the overall illumination around a bit (making things darker and brighter) is a great way to start "seeing" the world differently than it appears to the eye. Mood rarely happens right in front of you, but an artist can create it on command. This image proves that point. It was shot in the middle of the day with sun blazing. Look for the options and learn to see the world around you in another light.

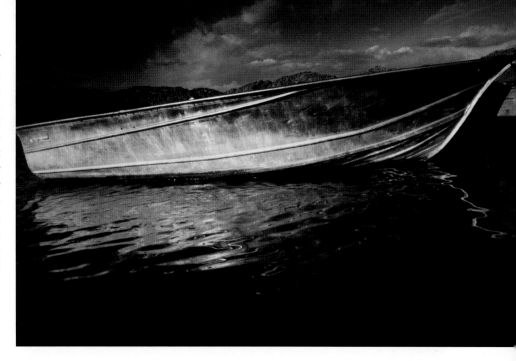

■ The term "bulb" refers to an old-school procedure for opening and closing a camera's shutter using a pneumatic pressure system similar to that found on a blood pressure cuff today. Squeeze the bulb and the shutter (which at that time was a metal plate) stays open. Release the bulb and the shutter closes. The bulb setting works similarly in our digital cameras today. Depress and hold the shutter button and the shutter stays open until you let go.

The reason is simple: $\frac{1}{4000}$ or $\frac{1}{8000}$ is a fast shutter speed. Very little light was allowed to enter the camera.

Now change your shutter speed. Set it to 30 seconds. *(Note:* This appears as 30" in your viewfinder.) Point your camera at something, focus, and shoot. Don't worry so much about holding the camera still.

The image captured will be very bright, probably white. The reason is simple: 30 seconds is a very slow shutter speed. A lot of light was allowed into the camera.

The good and bad news of this is easy to understand: every great image you have ever seen, every amazing photograph displayed in a gallery or found in a book or magazine lies somewhere between these two extremes, between white and black. You have proven that your camera is fully capable of taking both images. It's our job now to pull them out.

The hard part will be picking the perfect shutter speed for your image—or at least it used to be. Thanks to the advent of LCDs, there is no excuse for not getting the perfect light each and every time you are out with your camera. After all, you can see the results of your shutter speed choice immediately. If you don't like what you shot, then change it.

Now point your camera again at an object in front of you. Your goal is to take a photo of that object perfectly lit. You'll need to change the shutter speed of course, since your last choice didn't quite produce the perfectly lit image. You have learned that the perfect light lies somewhere between 30 seconds and $\frac{1}{4000}$ or $\frac{1}{8000}$ second, so take a guess. That's right, just guess at the "proper" shutter speed. Pick a shutter speed, dial it in, and shoot. Don't think about this too long, don't overanalyze, just do it. The important thing is to make the adjustment quickly. Don't hesitate, just make the adjustment and shoot. Examine the image. Is it too bright or too dark? Keep changing

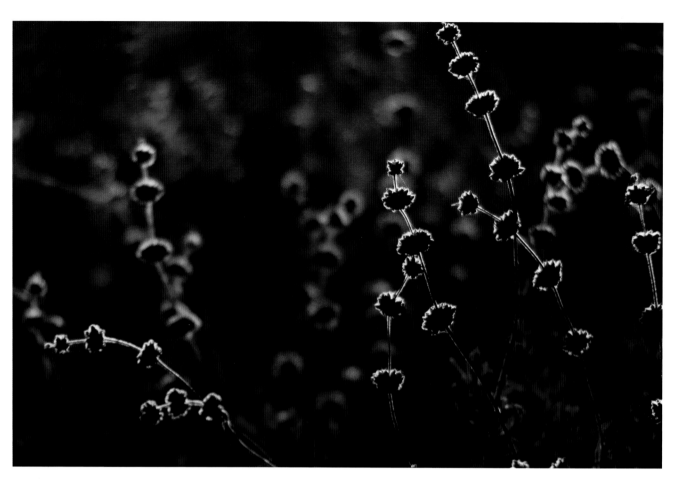

the shutter speed to add or subtract light until you feel that the subject is perfectly lit.

If you're having problems, make bolder adjustments. Spin that dial. Keep checking your LCD. Don't worry about the numbers right now, just look at the results. As you get closer to the perfect light, slow your approach. If you know you're close, there is no need to spin the dial ten clicks. Fine-tune the shutter speed until the image is lit perfectly. Do not ask anyone if they think the shot looks okay. This is your message, not theirs. Have some courage and make a commitment. Look at this picture and say, "Yes, I like this!" If you don't, then keep changing the shutter speed. Remember, the only thing you're concerned with now is exposure. If the image isn't well composed, don't worry. Just get your light.

Once you've got the light that you deem perfect, say the shutter speed out loud. Yes, we know it's weird, but say it anyway. Listen to the words, concentrate on the sounds, then say it again. What you're doing is building a memory. An audible memory reinforces the visual reference you made for yourself when you looked at the settings on the camera. Humans learn best when using more than one of our senses, and by saying this shutter speed out loud, you'll store this information more easily. It will be ready the next time you shoot.

Above—Reality looked nothing like what is pictured here—it was much brighter on the day this image was created. When you come upon a scene, consider the mood you want to convey and select a shutter speed that helps you capture your vision. Remember, you can't do this with your camera's auto features.

■ Don't bother with your camera's light meter. Its sole purpose is to give you average light—a "normal" photograph. An artist doesn't want "normal." We're searching for something more, something different, something that no light meter can possibly help us create.

Now, point your lens at something else, guess at the shutter speed, and shoot again. We're going to assume that you didn't start at $\frac{1}{8000}$ or **30** seconds this time, right? This is what experience offers. You stop making the same mistakes over and over.

Review the image you just created, adjust your shutter speed again, and shoot. Examine the light. Ask yourself if the image is the best it can be. Once you're happy, move on. Find an object in the brightest light possible and repeat the process. Then move to a shadow, then indoors, then back out. Don't worry about any other settings in the camera or any readings—just shoot some pictures. Say those shutter speeds out loud, keep making those guesses. Keep shooting and judging your images. You will build a cache of experiences that will help you to get better images, more and more quickly. There is no question that it will happen.

With each shot, with each set of images, your experience grows. As you move from subject to subject, from one light source to another, you are building memories as to which shutter speed works best at this particular aperture (f/5.6 right now, remember?). Later, you'll do this at other apertures, and you'll get better at that as well. Experience is an amazing teacher. Within just a few months (yes, we said *months,* sorry!) you'll know what your required shutter speed is under any condition, at any setting. This shutter speed will be yours and yours alone, based solely on what you want the image to look like. It will not be average; it will not be normal. This will be your picture, your light, your message—an artist's first conquest! Congratulations.

■ The amount of illumination present in your images is your responsibility. You can't rely on anyone but yourself to judge the light for you. You have an LCD, so use it. Do not settle. Keep adding or subtracting light until you have what you consider to be a perfectly lit image.

Below—A slow shutter speed not only allows you to make things brighter, it can also allow motion blur to happen in your camera—and sometimes (as in the above image) that can be a very good thing.

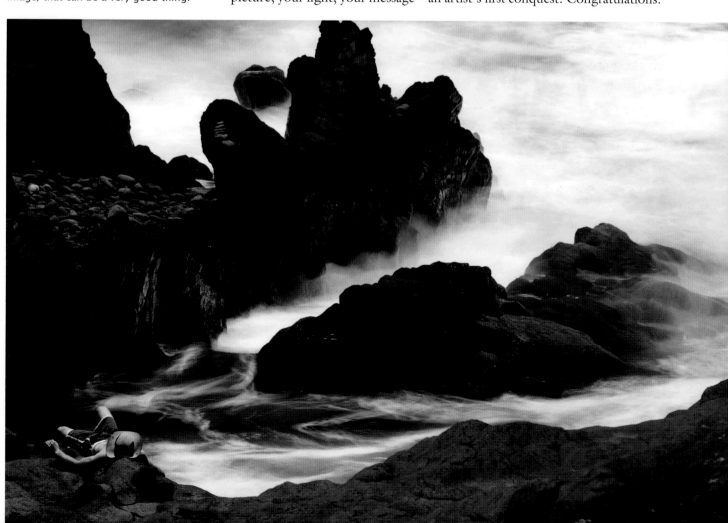

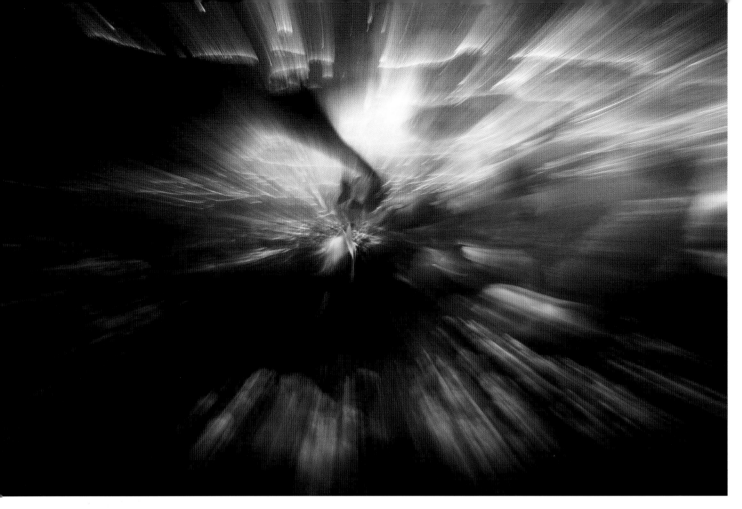

Above—Slower shutter speeds allow you to create a sense of movement in an image. By zooming your lens while you shoot a longer exposure (such as $^1/_{10}$ second in this underwater image) you can create a sense of movement. Zooming with a slow shutter speed is covered in chapter 4.

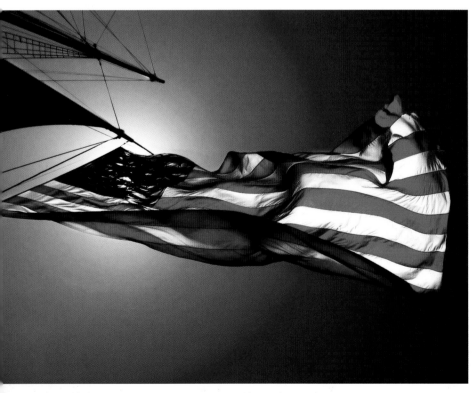

Left—A faster shutter speed can freeze dramatic action, no matter how fast the subject is moving. A shutter speed of $^1/_{1250}$ second froze this flag mid-flutter. **Right**—A slower shutter speed allowed the photographer to literally spin his camera (and, consequently, his image), creating a very unusual effect. The spinning technique is discussed in chapter 4.

■ The "f" in "f/stop" refers to the focal length of the lens, one of the two variables used to determine this number. The other is the physical size of the given aperture. Dividing the focal length of the lens by the diameter of the aperture produces the f/number. For instance, if the aperture is 25mm and the lens focal length is 50mm, then the f/number would be f/2. If the aperture is 12.5mm and the focal length is 50mm, the f/number would be f/4. The greater the f/number, the smaller the size of the lens opening.

Below—The aperture can be made larger or smaller. By choosing different-sized openings, an artist controls the amount of light allowed into the camera and also the depth of field (i.e., the amount of sharpness or blur in the image).

APERTURE

The aperture is an opening in the lens that allows light to enter the camera and strike the image sensor. The aperture can be made smaller ("stopped down") or larger ("opened up") by adjusting the aperture control dial on your camera. Obviously, the larger the opening, the more light is allowed to expose the image.

Apertures are represented by f/numbers. Larger f/numbers (such as f/8, f/16, f/32) indicate a smaller aperture size, while small f/numbers (such as f/1.2, f/1.4, f/1.8, f/2.8) indicate larger apertures. Opening up a stop (e.g., changing your aperture from f/5.6 to f/8) doubles the size of the aperture, allowing twice the amount of light to strike the image sensor. Stopping down (e.g., changing your aperture from f/8 to f/5.6) reduces the amount of light striking the image sensor by one half.

An artist chooses a particular aperture setting to allow him to shoot at a specific shutter speed (e.g., a fast shutter speed to freeze motion or a slow one to achieve a blur) or to ensure the desired depth of field (i.e., the focal range) in his image. The aperture selection is one of the first and most important decisions an artist makes when designing an image. It offers him creative control.

An Experiment. To fully understand the effect of your aperture selection on your image, hold one finger in front of your face about six inches from your eyes. Focus your eyes on your raised finger. Notice how the area beyond your finger (the "background") is completely blurry. The reason is simple: we've got two holes in our head (our eyes). Combined, they make one big hole (similar to our camera's aperture) and let in a lot of light. A lot of light creates an awful lot of visual confusion. It's hard to push past this. Humans can only see/concentrate on one thing because of all this confusion. This is neither good nor bad, it's just how it is.

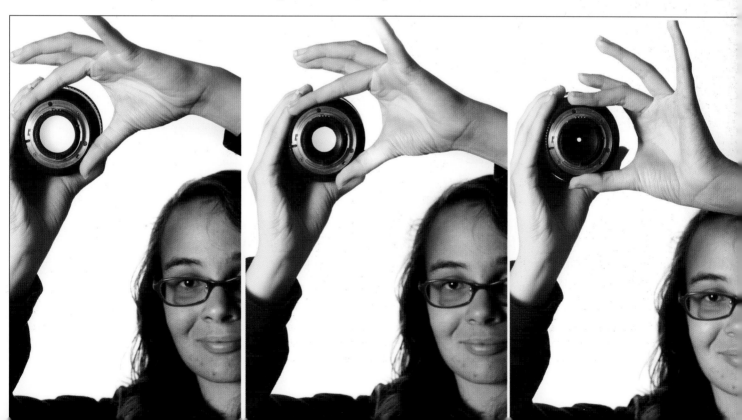

Left—When you look at the world naturally, you see it with an awful lot of light. This creates the rather drastic consequence of being able to focus clearly on just one thing at a time. Try it. **Right**—When there is an excess amount of light the brain can't sort it all. Backgrounds become blurry. Larger apertures in the camera work the same way. The more light we allow in, the less depth of field we achieve and the more blur (both in front of and behind our focus point) we get. As artists, we can use larger apertures to purposefully blur backgrounds, to make an image that better represents how we see our subjects—just one of them at a time.

Left—When you cut the amount of light, more things come into focus. When you try this experiment, be sure to cut all excess light from the scene. Close one eye tightly, move that small opening close to your open eye, and look through the hole. Make that hole smaller until you can only see your finger and what's behind it. **Right**—What you are seeing now is how light works. With less of it, more things come into focus. This works the exact same way when you reduce the size of the aperture (choose a higher f-number) in your camera to cut the available amount of light. With smaller apertures, you can ensure than more of the scene in front of your camera will appear in focus.

Refocus your eyes on the background (with your finger still up in the air) and what happens? Your finger is now blurry. Take note of how we (as humans) have to choose what to focus on. We adjust our focus point back and forth, moving from one subject to another. This is what it means to be a person, to be human. But as artists, we have a choice when we communicate. There is a way to keep everything in focus when using a camera, and we use it all the time.

Let's try another test. Make a very small circle with your thumb and forefinger and hold it in front of one eye. Close the other eye and hold up your finger again. Look through the hole at your finger. What do you see? Every-

Facing page—Blur can be an extremely useful tool to guide the eye to just a specific area of the image. Here, a large aperture coupled with an extremely close focus point created a shallow depth of field, blurring both foreground and background information. Look closely at the extremely small area that's in focus; this is the power of depth of field control.

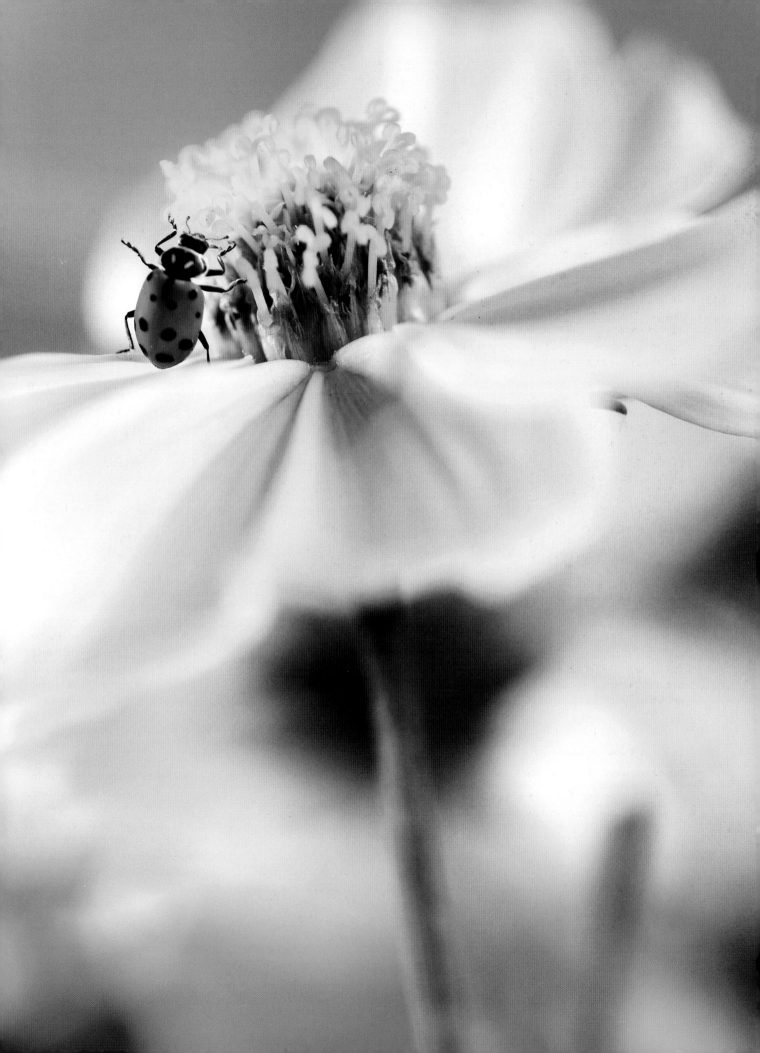

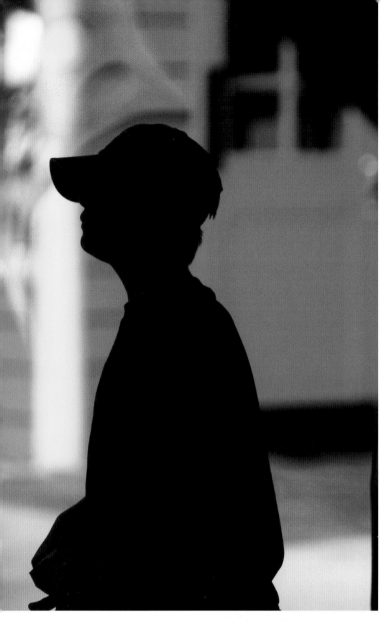

Left—Even when the image consists of simple colors and tones, an artist must choose his aperture for a reason. Here, a very large aperture (f/2.8) was chosen to blur the background, allowing for the silhouette to more easily be recognized. **Right**—A very small aperture (f/20) ensured that the depth of field captured stretched from the foreground subject all the way to the background. This then required the use of a slow shutter sped. Good camera-holding practices will help keep your images in focus.

thing from your finger to the background is now in sharp focus (if it's not, make the hole smaller and try again). Awesome, huh? With less light comes a greater range of focus.

The area that appears in focus is called the depth of field. By adjusting the size of the "hole," you controlled the amount of blur surrounding your subject. Again, larger holes allow for less depth of field (blurrier backgrounds), while smaller holes allow for more depth of field (sharper focus in the background areas). When you dial-in smaller apertures (larger f/numbers) in your camera, more things come into focus. Artists use depth of field to isolate individual subjects in a sea of blur or bring things into sharp focus.

Left—An f/1.4 aperture allowed the background to be completely blurred. Notice that only a small portion of our model is in focus. The depth of field in this image is shallow, spanning a short distance. When shooting portraits with wide-open apertures, beware: just one inch of movement by you or your subject and everything will be out of focus. **Right**—At f/2.8, we gain a bit of focus depth.

Left—At f/5.6, all of our model's face is in focus and the background is a bit clearer. **Right**—At f/16, our model is completely in focus. However, the light lost in choosing a smaller aperture dictated that a slower shutter speed was used, and some motion blur occurred. Check out her hair in the lower left. As an artist, it's your job to determine the effect of blur on your image.

Left—In this close-up image of a flower, you can see the minuscule amount of focus depth afforded by the same 50mm lens when shot at its minimum focus distance at f/1.4. **Right**—When the aperture is reduced to f/2.8, we see a significant improvement in focus depth.

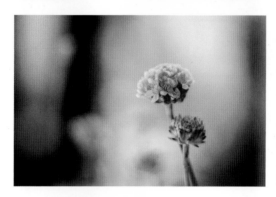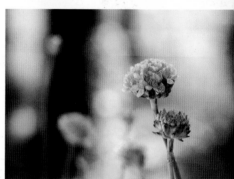

Left—At f/5.6, our flowers are in focus. The background is still blurry, though not as blurry as before. **Right**—At f/16, some clarity returns to the image, but we have a long way to go before the background becomes crystal clear. The problem is, this 50mm lens does not offer any aperture size options past f/16. To get the rest of the image in focus, we'll need to find another option.

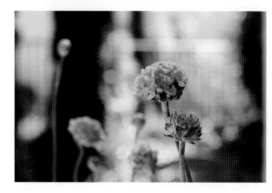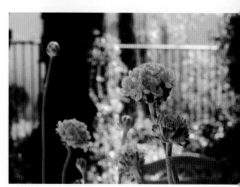

Aperture Options. By adjusting your aperture, you can achieve an array of spectacular blur effects. To maximize your creative options, you must discover the range of options each of your lenses offers. The portraits and flower images above were shot with a 50mm lens from the same location.

LENS FOCAL LENGTH AND DEPTH OF FIELD

Depth of field can also be adjusted by changing the focal length of the lens or the point at which you focus. Longer focal lengths (e.g., telephoto lenses) offer a shallower depth of field, resulting in an image in which more of the scene is blurred. Focusing closer gives you a similar blurry affect. Focus far away or use a very short focal length lens (e.g., a wide-angle lens), and most everything in your image will be in focus.

Artists use a combination of all depth of field controls when designing an image. They think through all of their options and, early in the creative process, determine the type of blur they want in their image and what they need to use to get it. Aperture choice is paramount. What's in focus is important, right?

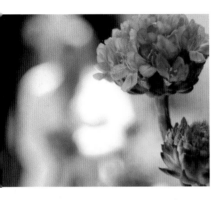 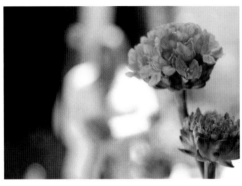 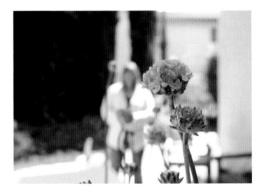

Left—This image was shot using a 55mm lens at f/5.6. Notice how the background is completely blurry and that only small portions of the flowers are in focus. **Center**—Changing to a 45mm lens used at f/5.6 allowed for only slightly more focus depth on the flowers themselves. The background is still completely out of focus. **Right**—When we choose a much wider-angle focal length, such as a 24mm lens (used with an aperture of f/5.6), we see our background more clearly; plus nearly all of the flowers are in focus.

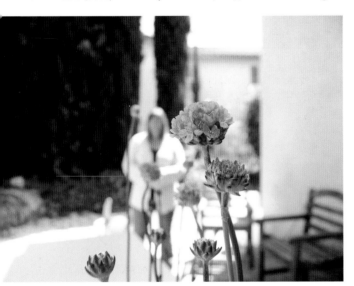

Left—Using a 18mm lens (still set at f/5.6), our flowers (from front to back) are now sharply in focus and the clarity of the background has improved dramatically. **Right**—A quick change of aperture size to f/22 and a corresponding adjustment to the ISO (to make up for lost light) brings everything into focus. As you can see, it takes some work to get everything from the tip of your lens to the mountains beyond your subject in focus.

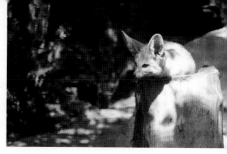

Left—In this image (shot with our zoom lens set to 90mm and our aperture set to f/5.6), you can clearly see a fence when we focus on it. But that's only one option. Look close behind the fence and take note of how powerful that blur is. You can't make out what's there. It's just a mind-numbing collection of shapes and colors. What will happen if we move that blur forward in an attempt to hide the fence? Can we eliminate it completely? You bet your blurry fence we can! **Center**—In this image, the focus point lies somewhere between our subject and the fence. It's obvious that front tier of graphic information (the fence) is blurring substantially now, and our background elements are becoming clearer. (We're moving the blur around.) If we were to focus even further away from the camera, we can expect the extreme blur (that was once behind the fence) to completely engulf the fence. **Right**—Once the focus point reaches the fox, our blurred fence is nearly transparent. Take note that our depth of field is still very shallow. Not only is the fence blurry, but the background behind the fox is too.

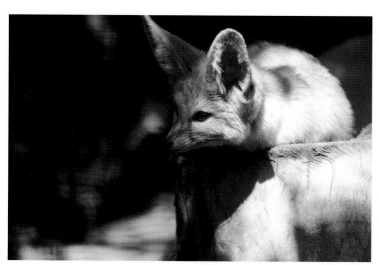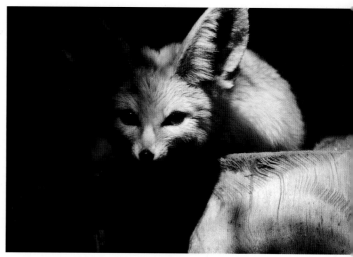

Left—To eliminate the fence completely (and blur the background behind the fox even more), a shallower depth of field is required. This can be accomplished in three ways: the aperture can be opened up, a longer focal length lens can be used, or you can move closer to your focus point. Since we can't get any closer to the fence and we are already shooting with our largest aperture, our last option is to choose an even longer focal length. In this case, we zoomed our lens from 70mm to 210mm. Longer focal length lenses compress available blur (both foreground and background). In this case, we were able to eliminate the foreground fence completely and isolate the fox with a blurry background. Notice how our depth of field only stretches a few inches beyond the fox's eye and ear. **Right**—To create an even more dramatic image, we selected a faster shutter speed to remove some of the light. We also selected more aggressive (higher) contrast and saturation settings. Keep in mind that this image in no way reflects how the scene appeared. Note that this process *does not* require an expensive (or professional) zoom lens. Any zoom lens with a bit of reach would allow you to create the same image.

APERTURES AND FOCAL LENGTHS: A POWERFUL COMBINATION

Blur is a powerful tool. Learning to control it well gives you options that few today understand. Take for instance the problem of shooting through a fence. With the right lens/aperture (in this case, an inexpensive 70–210mm lens set to f/5.6), you can make nearly anything disappear, including most any fence.

This image above was visualized, appropriate settings were dialed-in (including white balance, contrast, and saturation), and the image was shot with purpose. With enough practice, all of this can happen in the blink of an eye.

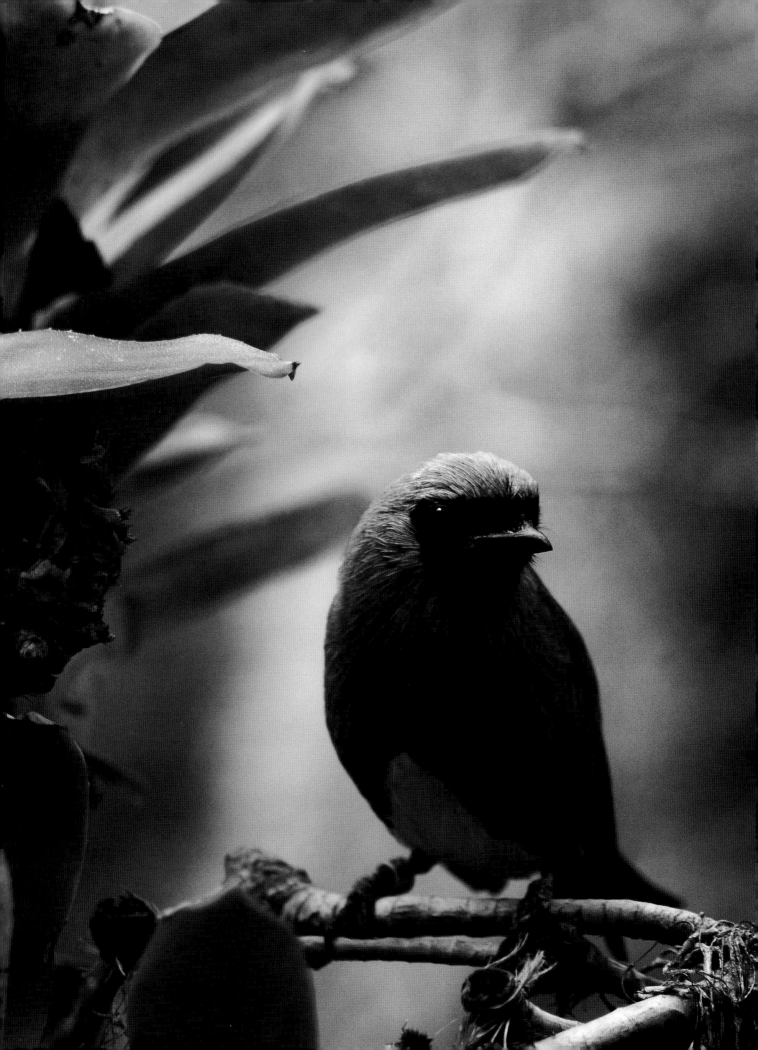

Above—Here is the image of the bird shot "as is." **Facing page**—Being able to control your aperture and shutter speed is the hallmark of a real artist with a camera. Here, a large aperture and longer focal length lens were chosen to blur the background behind the bird. The shutter speed was chosen to allow for the most dramatic lighting possible. The photographer lined up his subject with a very specific shape—one that he knew would blur into a wonderful backdrop. This technique, called "punching," is discussed later in this book.

Top right—Here we see the makings of a very special image. Notice how just one graphic tier is in focus. A long focal length lens and a large aperture were again used to create this extremely shallow depth of field. **Center right**—For this image, we adjusted our focus point to put it closer to the foreground graphic elements. Note how blurry the background became. **Bottom right**—Here, we chose a focus point dead center between the foreground and background elements. The shallow depth of field squished the previous elements into a delightful painted blur. This technique, called "ripping," is covered later in this book.

That's what building skill at something is all about. Photography is not just about shortcuts (or making your life easier), it's about becoming a real artist with your camera. It's about investing the time it takes to master something real.

RECIPROCITY

The aperture, shutter speed, and ISO setting on your camera (we'll cover ISOs in a moment) have a symbiotic relationship. In the previous paragraphs, you learned that opening up your aperture will increase the amount of light that is allowed to strike the image sensor. If you decide to open your aper-

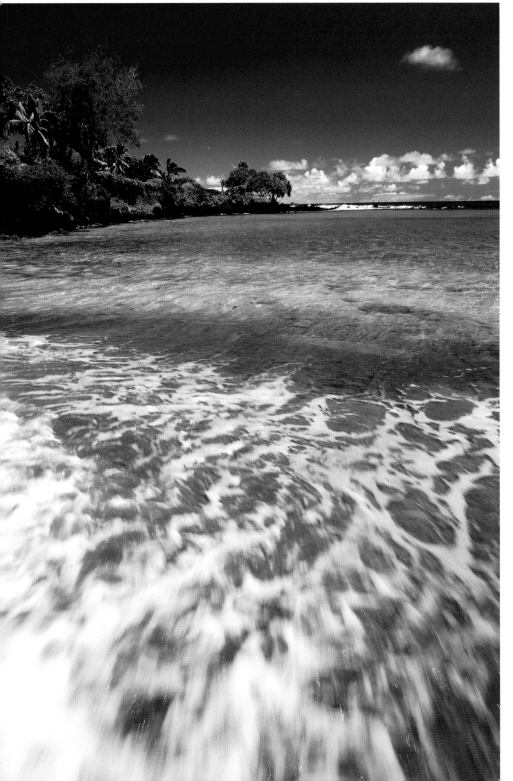

■ The word "stop" is a little old-school. It refers to the process of using removable metal plates with holes punched in them as apertures. Different plates offered different-sized holes, which, in turn, stopped different amounts of light from getting through to the camera.

Left—In order to achieve the desired slower-than-usual shutter speed ($1/20$ second) required to blur the water on the shoreline, a smaller-than-usual aperture (f/19) was chosen. To help, a very low ISO setting (100) was dialed in as well.

ture to create an image with more blur in the background, you will need to increase your shutter speed or ISO to reduce the amount of light striking the sensor, thereby maintaining the desired exposure. Likewise, if you decide to increase your shutter speed to, say, stop motion, you'll need to choose a larger aperture or lower ISO setting to ensure that the overall amount of light used to create your image remains constant.

An Exercise in Reciprocity. Grab your camera and set your aperture to f/5.6 and your ISO to 400, then choose a shutter speed that allows for perfect lighting in your image. Take a few test images to make sure lighting and focus is pristine. Once you have an image that you deem perfect, turn the aperture control dial five clicks to the right or count them as they pass by on the camera's control screen or in the viewfinder. (*Note:* You can probably change the amount of light added or taken away per click in your camera's custom features menu. You will usually have three choices—quarter, half, and full stops per click. For now, simply use the default setting and continue with the experiment.) Look at the f/number now—it's larger (consequently, the aperture is smaller). Take the image. As you may have guessed, when you review the image, it will appear darker than the one you shot previously.

Now, turn the shutter speed dial five clicks to the left to select a slower shutter speed. This will allow more light to strike the sensor, to make up for the light that was lost due to the change in aperture. This is reciprocity. It works like a teeter-totter. If one end goes up, the other end has to come down.

Artists use reciprocity all the time. For instance, if I wanted to shoot with a slower shutter speed in order to blur a waterfall, I would simply choose a smaller aperture. This smaller aperture would compensate for the increased amount of light the slower shutter speed would allow to strike the image sensor, keeping the image from being too bright.

As you're undoubtedly beginning to understand, photography is all about critical thinking. One choice creates a consequence that demands another decision be made.

ISO SETTINGS

Photographers look to ISO ratings to understand their film's or image sensor's sensitivity to light. Higher ISO numbers (e.g., ISO 400 or ISO 1000) indicate a higher sensitivity to light than do lower ratings (e.g., ISO 50 or 100). In the days of film, photographers looked to ISO ratings to help them select the appropriate film for the lighting situation in which they planned to shoot.

Digital cameras offer ISO settings, which work in a similar way. By setting the camera's ISO to a high number, a digital photographer can make their images appear brighter. The truth is, a camera's sensor can no more morph

■ ISO stands for International Organization of Standardization, a group that long ago created a mathematical formula that helped film manufacturers rate their products' sensitivity to light.

Top left—Bumping up the ISO setting will affect the color, contrast, and clarity of your image. This photo was shot at ISO 200. **Bottom left**—This photo was shot at 6400 ISO. The difference in image quality is startling. **Right**—Here is a close-up look at the noise that can result when higher ISO settings are used and how it can affect the color, contrast, and saturation of an image. Always use the lowest ISO possible (considering the situation and desired results). If you are forced to raise it excessively, expect pretty severe consequences.

into something it's not than you can. It can't just become more sensitive because you change a setting. With the help of some highly sophisticated algorithms, the camera "fakes" this additional sensitivity, in essence guessing at what the scene would look like if there were more light and creating the anticipated result.

Using high ISO settings can affect the quality of your images—less contrast and saturation and more digital noise will result. (Noise can be thought of as digital grain—small dots that hide color, mask contrast, and destroy clarity.) The goal for an artist is to keep the ISO setting as low as possible in all shooting situations. This doesn't mean you should set it to the lowest-available setting and forget about it. It's a tool. You will change it often depending on need.

There are two reasons to adjust the ISO: (1) To increase or decrease shutter speed alternatives; and (2) To introduce or eliminate digital noise for aesthetic reasons.

An Exercise. To understand how the ISO setting you choose will affect your image (in both positive and negative ways), try this simple exercise.

How to Do It. You'll want to do this experiment outside, in bright (midday) light. Set your aperture to f/5.6 and choose the lowest ISO setting your camera offers (e.g., 100 or 200). Manually focus on the landscape in front of you. Choose a shutter speed that you believe will give you perfect illumination, then shoot. Check your image, make any required adjustments to the shutter speed, and shoot again. Repeat this process until the image is pristine in both focus and light. (Remember to hold your camera steady while you shoot.)

Take another photograph, but this time, shake the camera while you shoot. Make sure the camera is moving while you press the shutter button. Your image is blurry, right? Most people would believe it to be blurry because of the camera movement. That's not quite true. The picture isn't blurry because you moved. It's blurry because the shutter speed is too slow for the situation. If your intention is to move the camera when shooting yet capture a "frozen" image, you simply need a faster shutter speed. You don't have to stop moving.

Now, adjust your ISO to its highest setting (1600, 3200, 6400) and adjust the shutter speed until your image is lit well. Shake the camera and shoot again. Notice anything different? Now your image is in sharp focus, even though you moved the camera during the exposure. Try it again if you like. Really shake that camera. It won't make any difference. There is no way that you (a human being) can move that camera faster than $\frac{1}{4000}$ second. It's just not going to happen. What this means is, if you wanted to make sure that all of your images were crisp and in focus, you could leave your ISO at that high number and be done with it. Keep using those fast shutter speeds and high ISOs, smile, and be happy. However, you may want to take a very close look at the quality of that last image. Look at the noise, the loss of color, contrast, and definition and ask yourself if it's acceptable. Our guess is it won't be.

Changing the ISO is an option, but it's not a very good one. It only adjusts the apparent amount of light captured, it doesn't add more. And as we said, you pay a price. Depending on the ISO chosen, the resulting image degradation can be pretty bad (no matter what the camera manufacturers say).

Reciprocity and ISO. While not quite as absolute as when you adjust your shutter speed and aperture, you can expect a similar reciprocal relationship when using your ISO. A one-click change in the shutter speed or aperture will usually equal a one-step change in the ISO. The reciprocal nature of the ISO (from what we've found) works best at its lower settings. Higher ISOs will usually produce some unpredictable and unfavorable results (no matter the camera, no matter what the manufacturer promises).

ACHIEVING GREAT FOCUS EVERY TIME

There are only two reasons why your images will be blurry: because your shutter speed was too slow or your depth of field was too shallow. That's it,

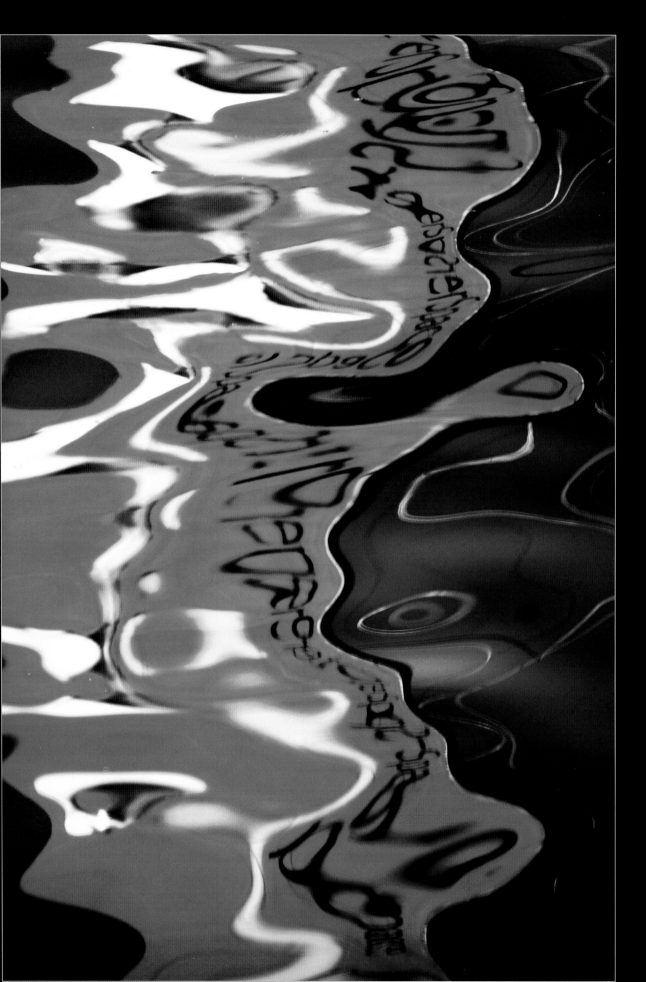

Facing page—Creative photography is a dance between aperture choices, shutter speeds, and ISO settings. You set one of the variables to ensure the effect you want and then adjust the others as needed to ensure that the amount of light entering the camera produces the exposure you are after. It will take some time to gain a full understanding of how this works, but as with any other art form, the journey is worth the sacrifice.

no more. As you saw in the fast shutter speed/high ISO experiment, you can achieve pristine focus even if the camera is moving dramatically when the shutter is triggered. You also learned that by choosing the correct aperture size you can get more than one thing in focus. Of course, each of these decisions come with consequences. The higher the ISO, the less real "quality" you'll receive. Smaller apertures require more light, so a slower shutter speed (which may create a blurry photo) may have to be used. At first, juggling these options, decisions, and consequences may prove difficult. To stay on track and to keep your images in the best-possible focus throughout, we offer these simple suggestions:

- Don't breathe when you shoot. Yes, we know it sounds like a no-brainer, but as we've discovered, this is one of the biggest reasons for blurry images from new shooters. People simply forget that when they breathe they are actually moving. Their lungs are inflating and deflating, causing their camera to move forward and back. If you want a better chance of shooting an in-focus picture, don't breathe when you shoot.

- Turn your body toward what you're shooting. While it looks really cool to twist your body when you shoot, it doesn't help your chances of focus. If your body is twisted in any way, your muscles are straining. You are actually fighting your own body to maintain its position. Don't do it. Simply focus on being relaxed. Aim your body toward what you are shooting and gently squeeze off your shot. Don't push the shutter in forcefully. There is no need to do that, and it makes the camera move as well.

- Find your camera's center of gravity. Rest your camera in your left hand so it sits gently, without wobbling or leaning forward or back. This means you may have to support your camera from under the lens (if you're using a long lens). The less you have to strain to keep the camera in its shooting position, the less chance you have of it moving.

- Only shoot in your "shutter speed safety zone." This is a big one, and it's one we recommend to all our students. If you simply double the focal length of the lens you're shooting with and use that number as your minimum shutter speed, then your images stand a much better chance of being in focus. For example, if you were to shoot with a 50mm lens, then your minimum shutter speed would be $1/100$ second. If you were shooting with a 20mm lens, then your minimum (workable) shutter speed would be $1/40$ second. If you dip below this number, your chances of a blurry image increase dramatically. This "double your focal length" safety zone only works if you and your subject aren't moving. If either of you are, you will need even faster shutter speeds. Plus, this only works up to a 60mm lens. Once you use a longer (telephoto) lens, you'll need to triple its length to find your shutter speed safety zone, meaning that if you use

a 100mm lens, your minimum shutter speed should be at least $^1/_{300}$ second. Bear in mind that these are only recommendations, and depending on how well you adhere to our other suggestions you may need much faster shutter speeds.

- Always check to see if your depth of field is deep enough to cover your entire subject or desired focus distance. You will have to employ your depth of field preview button (described below) to find this.

Visualizing Depth of Field. Your camera comes with an automated aperture system. The aperture only shrinks to its dialed-in size when you press the shutter button. That means that whenever you use an aperture other than your largest-available aperture and look through the viewfinder, you are not actually seeing what the image will look like once it's taken. Let's look at a practical example. Imagine you were asked to photograph two children. If you focused on the first, the other child would appear blurry through your viewfinder, even though you had selected an aperture that would ensure that both subjects would appear in focus. This makes learning real photography tough for the artist.

Luckily, there is a button on your camera that can solve this problem. It's called the depth of field preview button, and it's the most important button on your camera. The depth of field preview button disengages your camera's automated aperture system, allowing you to see the depth of field as it will appear in the final image. To understand how it works, it's best to see it in action. Grab your camera and dial in a very large aperture (small f/number). Flip your camera around and look into the lens. You may want to hold the back of the camera up toward a bright light. Notice the size of the aperture in your lens. Change the aperture to its smallest opening (largest f/number). Flip the camera around again and look into the lens and you'll see that the physical size of the hole hasn't changed. It's still big! This proves that what you see in the viewfinder is not what you'll get when you take the picture. Push in the depth of field preview button (with the camera still flipped in front of you) and hold it in. The aperture will now appear smaller.

Flip the camera back around and focus on a small subject in front of you. Make sure that the background appears blurry. Look close, specifically at the blurry background. Depress (and hold in) your depth of field preview button and watch how the blur is cleaned up—it's more in focus. This is how we get more than one thing in focus. We choose an aperture based on a needed depth of field—such as two children in focus rather than just one. We then check this aperture setting by pushing in our depth of field preview button. If we need more focus area, we make the aperture smaller. Once we see that we have the right setting, we choose a shutter speed and ISO that allows us to capture the amount of light we are after.

■ If you're unfamiliar with the depth of field preview button's location, check your camera manual now. If you discover that your camera doesn't have a depth of field preview button, write an angry letter to the camera manufacturer telling them that the reason you bought an SLR was for control, and how dare they think you didn't want or need it? Then, buy a different camera. Seriously, it's that important.

DETRIMENTAL DEFAULT SETTINGS

All digital cameras come with certain default settings already in play. For most photographers these are inconsequential options that have little to do with their hunt for pretty pictures. For an artist though (seeking enlightenment and truth) each of these can wreak havoc with basic message building skills, destroy any chance for success, and cripple their ability to grow. These must be turned off.

Auto ISO. Since we'll be creating mood (choosing the perfect illumination for our images) and using motion blur to our advantage, we have to control the amount of light in our images and the way it is represented. Auto ISO attempts to maintain a "normal" amount of illumination in an image (based on thousands upon thousands of other peoples' "average" photos). It also ensures that the shutter speed is high enough to eliminate the chance of motion blur. This is not what we want. Turn off this feature, choose an ISO that suits your purpose, and move on with your life.

Auto Focus. To understand depth of field and all its artistic implications, you must abandon your reliance on auto focus. While it's true that there will be situations when it's useful, it's best to focus manually when painting with your lens. Remember, we're not shooting pictures of things, we are expressing ourselves with our cameras. How can a camera auto focus on a feeling?

Auto White Balance. When adjusting your white balance, you are simply adding red or blue to your image. If you set the Kelvin temperature higher in your camera, your image will be more red. When you select a lower Kelvin temperature, your image will appear more blue. We use our camera's white balance settings to help create mood in our images. For us, it's not about making a white object white under certain lighting conditions, it's about establishing mood in the picture. A redder image is seen as more aggressive, while bluer images appear more passive. When we see the image on the LCD monitor, we can quickly make adjustments as we see fit. We can add more blue or take away the blue cast by adding more red. If you're unfamiliar with the options that your camera's white balance feature affords, take some time

■ Yes, the world appears darker when you push in the depth of field preview button. That's what happens when you cut the amount of light. Don't worry about how dark the world appears when using this button; it makes no difference to your final image. Remember this button's name. It's called the depth-of-field preview, not the how-bright-my-image-will-be preview. Your shutter speed, flash, or ISO setting will give you all the light you need.

Left—This image was shot with the camera's white balance set to 5200 degrees Kelvin. **Center**—This image was shot with the camera's white balance set to 2500 degrees Kelvin. **Right**—This image was shot with the camera's white balance set to 10,000 degrees Kelvin.

 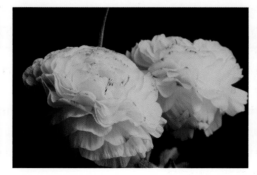 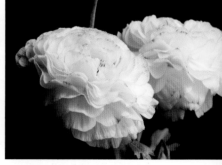

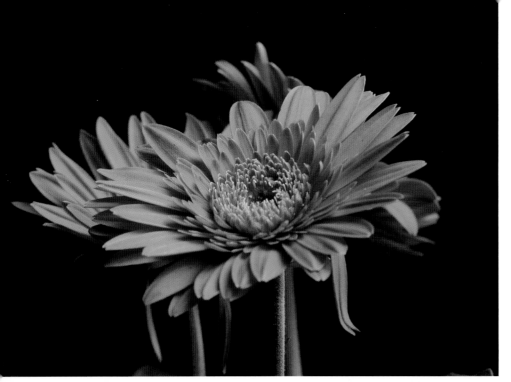

Top—This image was shot with the camera's internal contrast and saturation settings set as low as possible. **Bottom**—This image was shot with the camera's internal contrast and saturation settings set as high as possible.

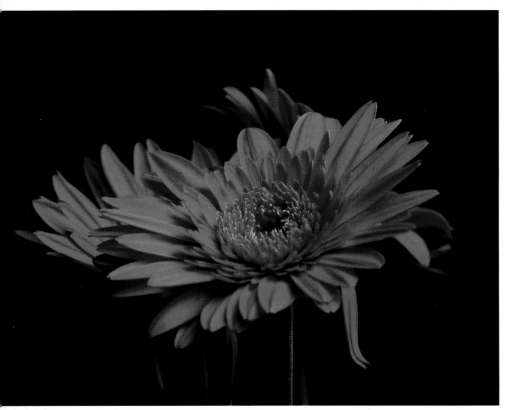

to play with your options. You'll love the impact that adjusting the white balance can have on your images.

Aperture or Shutter Speed Priority Mode. Our aperture and shutter speed options are key to painting with our lenses. When you set your camera to either aperture or shutter priority mode, you relinquish control over those artistic possibilities. Remember, the auto features of a camera are designed to

read an average scene and produce average results. We're not after average. We're creating exceptional art.

Auto LCD Brightness. An LCD monitor set to auto brightness will adjust its apparent light levels based on the light around you. You can't make accurate decisions about your image if the image itself keeps changing. Yes, this means that you will have to get used to seeing the monitor in bright light, and you'll have to deal with the glare the best you can. Step under a tree, put the camera in the shade, walk inside if you have to. Do whatever it takes to see that monitor clearly and accurately. Make sound decisions from an unwavering illustration.

Auto Contrast/Saturation. All digital SLR cameras will allow you to adjust your contrast and saturation settings. Some will even let you play with image sharpening and hues. These are powerful tools. We want to make sure that every creative aspect of our image-making process is under our control—not the camera's. Keep the auto features turned off. You're in charge from now on—*not* your camera.

IN CONCLUSION

Thanks to the camera's LCD, we can notice if there is something about our image that doesn't look perfect and fix it right on the spot. If you don't know how to solve the problem, search for answers. Try new things, adjust some settings, and experiment with new ideas. This is what it means to be an artist.

Below—A camera can't design, a lens can't compose, and a sensor can't pick the best light for your message. That takes someone special, that takes an artist, that takes you.

SOME INSIGHT

Often we'll challenge our new students to take a picture of us while in the field. We ask them to choose a large aperture, pick a low ISO setting, and find a shutter speed that renders us perfectly lit. They shoot, scrutinize, and make adjustments. When we see them smile, we ask them about the shutter speeds they have selected. "$1/60$," comes an answer. "$1/125$" comes another. From the corner we hear "$1/250$," "$1/30$," "$1/500$," and even "$1/1000$." Somewhere along the line at least one will say "$1/2000$." At that moment, they look at each other oddly, thinking they all made a mistake. We then ask them to show their images to each other. The images all look different. "Which is right?" they ask. "They all are!" we reply.

Art is unique, and it is perfectly acceptable for our images to show this. Being an artist is about speaking with your own voice. It's about being able to stand tall and say, "I like this." It's not about being average. You don't try for compliance when you yearn for individuality.

"Look at your own image closely and you'll learn a lot about yourself," we continue. "Is it bright and cheerful or dark and brooding? You chose that light because you liked it. It's as much a reflection of you and how you feel as it is about what's in front of you. This is what it means to be an artist with your camera." We then ask them to take the very same photo of us with their cameras set to auto mode. We ask them to share their shutter speeds. All have similar numbers. We ask them to show each other their photos again. The smiles disappear. All of the images look the same—average and "normal."

The lesson learned is an important one: you can't be an artist when you're shooting in auto mode. You can only be like everyone else.

Right—The amount of illumination in your message is up to you. No machine can ever know what it is you want to say or how you want your picture read by a viewer. Never bend to others' impressions of your lighting. This is photography; there are no rules, no standards of compliance. The fact that one person like his images lit one way does not make that the rule for the rest of us. **Facing page**—Taking responsibility for your images is the first step toward achieving artistic freedom. You have to start creating pictures that you're proud of—images that are lit the way you choose. Just because your images don't faithfully represent the way the scene or subject looked to the naked eye does not mean your approach was wrong. The amount of light you capture is a personal choice. It always has been. You simply have to ask yourself a question: does this illuminate my message well? Do I like it? If the answer is yes, you've done it. This image, for example, does not resemble the scene as it looked in "real life." A fast shutter speed was chosen to create the moody atmosphere.

Top—These images show the effect that shutter speed selection has on the amount of light in the image and the resultant mood that is achieved. None of these photos illustrate the "correct" exposure. If the artist's intent was to show you the building with detail, then the first image is lit just fine. If his intent was to show you what the weather was like that day, then the third image is perfect. If he wanted to show you a little of both, then the middle image is right on the mark. The choice as to which shutter speed illuminates a picture perfectly is always up to the artist. It's not simply about capturing what's in front of you, it's about sharing with others how that something made you feel. **Bottom**—It's all about what could be. An aperture of f/4 and a shutter speed of $^1/_{30}$ second allowed a lot of light to pour into the camera for the top photo. Notice how a sea of white light surrounds the subject. This is not how the world appeared at that moment. To create the bottom photo, the aperture was changed to f/8 and the shutter speed increased to $^1/_{125}$. This took light away from the entire image, making the subject dark and the background "normally" lit— once again, the image was different than the scene actually looked. Working in manual mode, these are but two of the many choices the photographer had. If he had been working in auto mode, neither would have occurred.

THE ART OF SEEING

If you're like us, your desire to become an artist with your camera is overwhelming. You're probably tired of all the average and normal pictures you and everyone you know are taking and want something more. To accomplish this, you'll need to see beyond some very basic human biases and then push even farther until you are able to control how that image "feels" to others who view it. You will have to visualize an image that in no way appears as the subject matter does in real life and, if you haven't guessed, there are no auto settings that can do this for you. So, set your camera to manual and let's start making magic!

One of the best ways to begin the transformation from photographer to artist is to understand how we see the world. We are all locked in a very limited box of vision, a universally shared point of view that only allows for a small portion of the real possibilities. To grow, we have to beat this.

OUR LIMITED VISION: AN EXPERIMENT

Look around you right now for the deepest, darkest shadows you can find. Now, visualize what that area would look like if it were brighter. Picture setting up twenty lamps all around you, each with a 250-watt bulb or higher. What would that shadow look like? What would the rest of the room look like? Pretty bright, right? Yet without those extra lights, you can't see this imagined brightness. You can only imagine what it would look like, visualize a possibility.

Your camera can create that image right now. Try it if you like. Grab your camera, set your aperture to its largest setting, select a low ISO setting, choose a shutter speed that elevates that shadow to "normal," and see what happens. The whole scene will get brighter. It doesn't have a choice.

Unlike our eyes, a camera can capture the extreme ends of illumination—pure white and pure black and everything in between. By simply changing the shutter speed we can explore these options, making our images darker or brighter, discovering worlds that are hidden to most. One of the first things an artist in training should do is train himself to see something differently, to visualize and explore his options. To this end, we ask our students to start shooting "moody" pictures as quickly as possible.

CREATING MOOD

In photography, "mood" is a pretty easy concept to grasp. Anytime the light plays a major role in how an image "feels" to a viewer, it's moody. Mood is not something that just appears in front of you. You have to create it by visualizing how something could look if you changed the shutter speed, aperture, or ISO setting, making an image brighter or darker than it appears to the eye. The images on pages 58 and 59 show the effect of establishing mood.

■ Most people want to capture an image of the things in front of them, lit the way they appear to the eye. An artist breaks this boundary and explores extreme options. He sees possibilities others can't. He sees mood when there is none in front of him.

Left—Though the feel of this image is quite different than that depicted by the image on the facing page, the artist used the same creative process. He simply lined up two varying degrees of brightness and chose a shutter speed and aperture setting that would render his subject bright and his background even brighter. This is not how the scene appeared in real life. The subject was actually in deep shadow, while the outside was quite bright. For an artist with a camera, "moody" doesn't always have to mean dark. We call any image in which the light plays a major role "moody"—including those that appear bright and cheerful. "Happy" is a mood too, right? Right—In this set of images, you can see the dramatic differences in the outcome of your images when you adjust the light yourself. The more important thing to notice in these photos, however, is that what you see is only one choice. The unseen options are often the ones that give us the best photos.

IN-CAMERA SETTINGS

Facing page—The secret to creating great moody images is recognizing opportunities when they present themselves. The scene pictured here did not actually look like this. The bird in this image was simply sunning itself. To create the black background, the artist simply positioned himself so that the bright bird was in front of a large shadow. The shadow was not black. The artist took away light by selecting a faster shutter speed, lower ISO, or smaller aperture, checking his results, and adjusting his settings until he created the mood he had imagined.

Your dSLR features options that will help tremendously when creating mood or dialing-in a "feeling." These include contrast, saturation, and white balance. You may also have a hue slider and possibly a sharpness option as well. We teach our students to become very familiar with these and to use them to "dial-in" how they feel about something—*before* they shoot the picture. We realize, of course, that this advice runs counter to what most professional photographers might suggest or practice. While there is nothing wrong with "working" your images after the fact, true creativity doesn't flow from your computer mouse. The images in this book were all envisioned first. The problem with relying on after-the-fact editing is that it doesn't teach you how to visualize a possibility. It doesn't offer you a chance to grow as a photographer, it just fixes your pictures. We also ask our students not to shoot in RAW as this (again) stifles their creativity. Shooting in RAW gives our students an out. We would rather they attack things head on.

We simply offer an alternative and present a challenge. What if you made the exact right white balance, contrast, and saturation choices while in the field? What if those choices were actually part of your message-building process and you were okay with the results? What if you didn't need to fix anything after the fact? Wouldn't that be a good thing?

Try it on for size if you like. Make some of those adjustments yourself

in-camera based on how you feel at the moment. This is when you're most in-touch with your subject or message. Reach out for that feeling and start dialing it in. You won't regret the decision.

Most every dSLRs allow you to make contrast and saturation adjustments in-camera. Contrast refers to how bright and dark tones appear (how black is black and how white is white). Saturation is all about the richness of colors. When deciding on contrast and saturation settings, you have to know what to expect. You will need to take several test images to see how your camera's sensor reacts when these adjustments are made. For each option, shoot using the highest-available setting, then use the lowest settings and compare the results on your LCD and your computer monitor.

White Balance. All light is not created equal. Daylight, for instance, tends to have a blue cast, while incandescent light tends to appear warmer or redder. Digital cameras offer a white balance feature that can be used to eliminate the color casts and render your images in a more neutral manner; you can set the camera for the known color temperature of the light source illuminating your scene (e.g., between 2500 degrees Kelvin and 10,000 degrees Kelvin) or simply select a white balance preset that depicts the type of light you are shooting in (e.g., sunny, shady, cloudy, tungsten, fluorescent, etc.). Though you can use you camera's white balance settings to eliminate color casts, you can also use them to make an image warmer or cooler than it appears to

Below—The image on the left was created using the lowest contrast and saturation setting, while the image on the right shows what happens when they are maxed out. Your camera may also allow you to adjust for image sharpness and hue. We recommend experimenting with these until you can easily forecast the results. **Facing page**—Just because the world appears a certain way doesn't mean that's how it has to be captured. A true artist pushes not just his equipment but his vision as well. He sees things others can't and does things others won't. Here we see the effects of a very low Kelvin temperature setting being chosen in-camera.

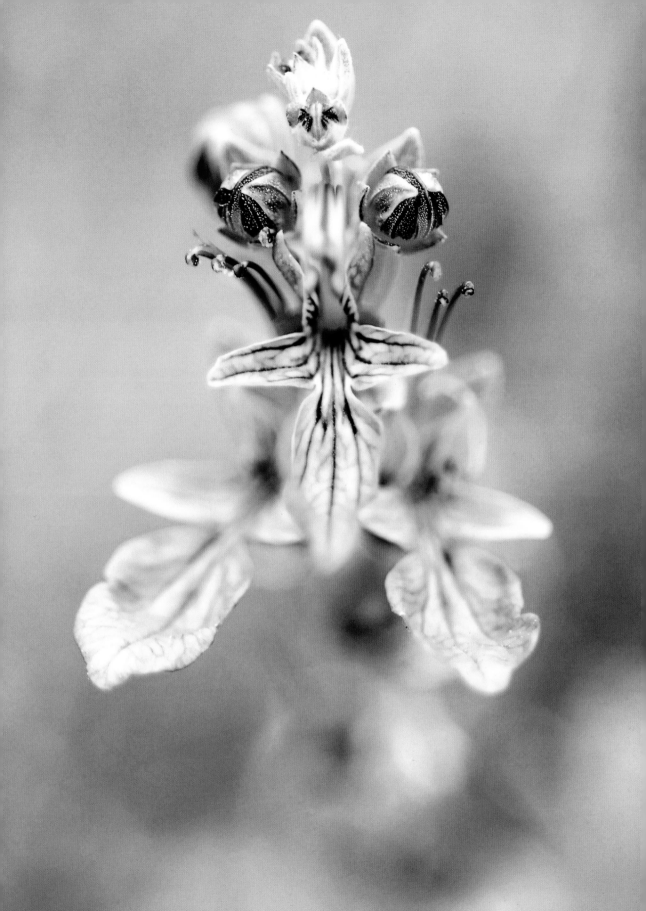

the eye.

CREATING A BLACK BACKGROUND (BY THE NUMBERS)

We often ask our students to create a black background as a test of their visualization power. We do this both as homework assignments and as personal

 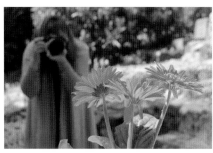

Left—Start by setting up a shooting table and grabbing a willing (yet somewhat tall) subject (flowers usually work best). You'll want to do this experiment on the brightest day possible, ensuring that there are plenty of shadowed areas around you. Position your table in such a way that half is in shadow and the other is not. Make sure that there is a place behind your table that has a very large shadow available. Place your subject in the brightest spot on the table. **Center**—Adjust your camera's aperture to a setting that will give you the perfect amount of depth of field. Check this with your depth of field preview button. Choose a low ISO setting in-camera and change your contrast setting in-camera to its highest setting possible. Saturation settings should be adjusted after you review your initial images. **Right**—Position yourself so that your super-bright subject is in line with your super-dark background. Move in closer (or zoom in) to your subject. Make sure that there is nothing but the bright flower and the dark background in your viewfinder. Set a shutter speed of $^1/_{60}$ and take the picture. Examine your image. If your flowers appear too bright, begin increasing your shutter speed.

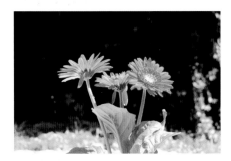 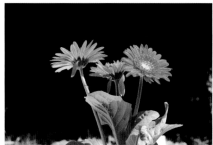 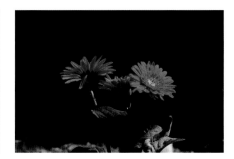

Left—In this example, a shutter speed of $^1/_{60}$ resulted in an image that (for the artist) was too bright. A faster shutter speed is needed. Also notice that at this slower shutter speed the flowers appear blurred due to excess motion. (They were blowing in the wind.) **Center**—At a shutter speed of $^1/_{100}$, a lot of light is taken away and we see our flowers and our background get darker. Motion blur has also been solved with the faster shutter speed. **Right**—With a shutter speed of $^1/_{400}$, mood has been established and an image that in no way resembles real life begins to emerge.

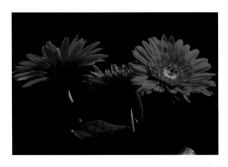 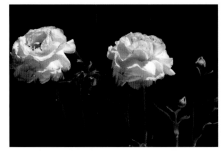

Left—A tighter angle of view and a smaller aperture provide us an exquisite close-up image that's impeccably sharp, stunningly vibrant, and simply magnificent. Better still, we've made the image with no special lenses or expensive flash systems—right in the backyard. Who'd have imagined it was possible? **Center**—In this image, we see Robin replacing the red flowers with white ones. **Right**—At f/18 and $^1/_{250}$, we start seeing the world in pure focus and marvel at the amazing shapes, shadows, and colors that have been around us all along. The artist is starting to emerge.

Left—Start as before, looking for light. Find something very bright in front of something very dark (preferably, a large shadow). **Center**—Position yourself to ensure your subject and background are the only things in the frame. Use whatever lens it takes to accomplish this. Adjust your camera's internal settings to achieve an optimally moody image (high contrast/high saturation) and choose an aperture that gives you the perfect depth of field, testing it with your depth of field preview button. **Right**—Start shooting the image and examining the results. If your image is too bright and you have yet to achieve perfect moodiness, start increasing your shutter speed. Make sure that there is only a bright subject and a dark shadow in your image. In this image, there are too many competing tones. To improve the image, get closer or use a longer focal length lens.

Left—Start adjusting your shutter speed if needed. In this image, our shutter speed was $^1/_{640}$. In these circumstances, it was not fast enough to create mood. We need to take away even more light. **Center**—At $^1/_{1000}$, our blacks look stunning. It's time to crop in a bit tighter on our subject. **Right**—In this image, we decided to use a smaller aperture (f/16) to pull in some detail. Since we changed the aperture from f/5.6 to f/16, we lost light. To compensate, we decreased the shutter speed to $^1/_{320}$. If we felt that this shutter speed was too slow to hold steady, we would simply use reciprocity once again and raise the ISO to match.

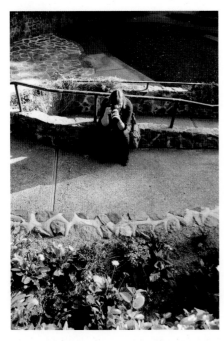

Left—Changing position gives us a different viewpoint and other options. **Center**—Shooting vertically allows for other dramatic options. Since we had more flowers, we dialing in an even smaller aperture (f/18) to record achieve more depth of field. **Right**—It's amazing what you can create with your camera on a bright, sunny afternoon. Photographers say evening and morning are the best time to shoot. It's a good thing we're artists. It would be a shame to overlook a great image-making possibility.

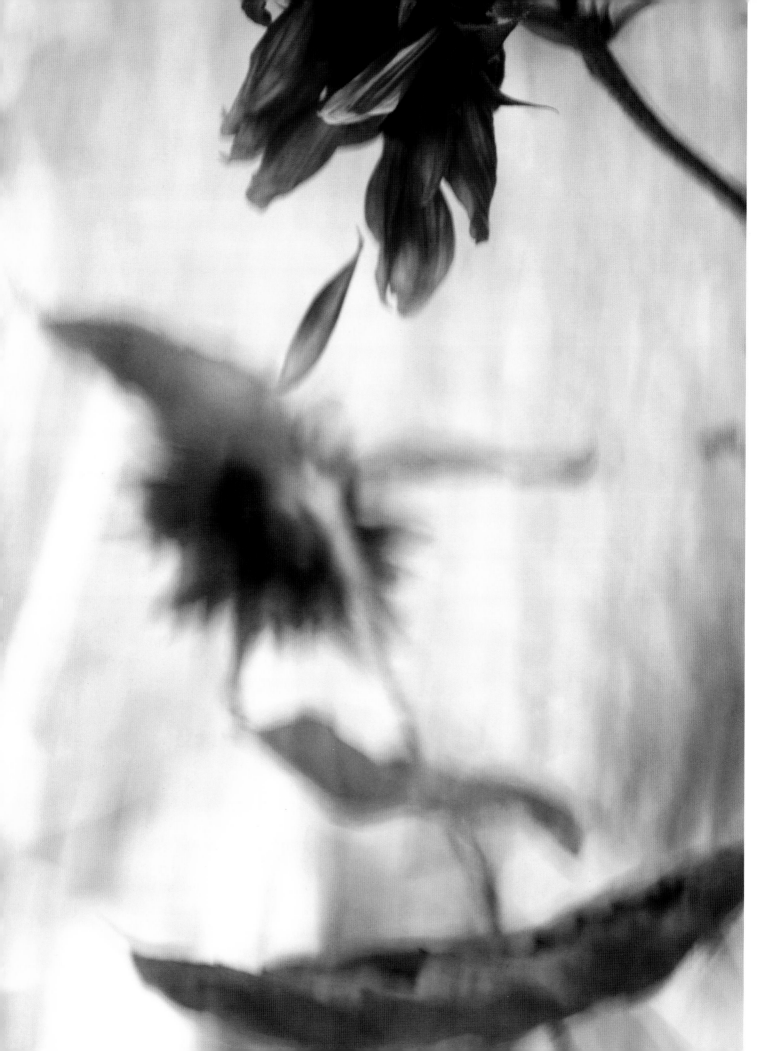

4. TIERING AN IMAGE

To be an artist with a camera, you must "see" beyond what you see. You have to train yourself to look for and create the unusual. You have to be different. You have to be unique.

TIERS OF GRAPHIC INFORMATION

Humans see the world one object at a time. When our retinas are filled with light, a lot of visual information is transmitted to the brain. Our minds select one thing, be it an object or an aspect of the scene in front of us (what this is depends on our biological, psychological, and sociological preferences) and we analyze it. We then move on to process other chunks of visual information—or in other words, other tiers of graphic information.

Photographers make it a point to take pictures of these singular chunks of information. They point their cameras at one tier and do what they can to make it look good. Artists, on the other hand, must learn to put more than one tier of graphic information in their image, creating something in-camera that is entirely different than what their eyes see. This is not point-and-shoot photography. Think about the simple black background we created in chapter 3. Creating the mood in the image required two specific tiers of graphic information to be present and aligned perfectly—a bright foreground and a dark background. We then simply put these two tiers of graphic information together in an aesthetic way, choosing a shutter speed or aperture that created something that wasn't there. This isn't the way most people use their cameras; however, it's how an artist paints a picture.

When creating a painting, an artist usually begins by establishing the background (his first tier of graphic information). On top of this he paints another tier (maybe a tree or a stream). Next, he adds yet another tier (maybe rocks, boulders, plants, or a person). He starts from the back and builds his image one graphic tier at a time. If we were to take the same approach in our images, we could also paint our way to success. The problem, of course, is that we're human and we're used to ignoring these multiple graphic tiers. We look for singular subjects that are "pretty" and do our best to represent that beauty in our images. We don't look at a smorgasbord of lines and shapes and get excited about the possibilities. Well, the good news is, with training, you can learn to use all of the information that is in front of you. When you do, you can make a serious statement with your art. You can start to punch a hole in reality.

■ A tier of graphic information is any group of lines, shapes, patterns, colors, or tones that create a subject or item. For instance, even though a car is comprised of many graphic elements, we group the information together and call it "car." Doing so simplifies the way we understand our world. Our brains still recognize the individual parts as graphic elements on a very base level, but they've learned to combine the elements quickly.

Facing page—This is an example of an in-camera painting technique called ripping. To produce the effect, the artist lines up tiers of graphic information and then uses the chromatic and spatial aberrations created in his lens to his advantage. Painting with your lens takes skill, which takes time, dedication, and devotion. The results, though, are certainly worth the effort.

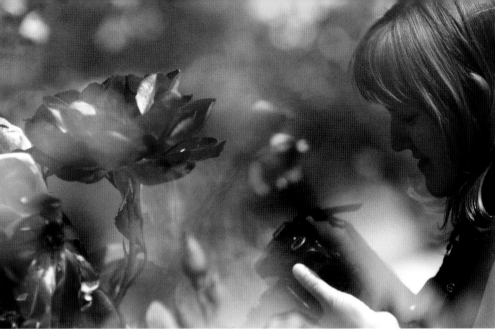

Left—In this abstract image, many graphic elements (or tiers) were brought together to create a new reality. While no single tier is in sharp focus, the idea of color, shapes, and patterns is clear. Sometimes art simply means exploration. Sometimes art can be abstract. **Right**—Creating means seeing and using, putting things together, visualizing an end result, and doing something about it. You can't do that if all you are doing is reacting to stimuli. To be an artist, you have to grow as a person; you have to learn to see beyond the singular subject. You need to start seeing tiers of graphic information instead of just the things around you. Here, the photographer used the in-camera multiple exposure option to layer several tiers of graphic information. His first tier was an image of the foreground flower. He used a very shallow depth of field so that he could blur out any extraneous information. For the second tier (and second exposure) he focused his lens on his model, once again using a very shallow depth of field to blur out everything else. Once all of the layers were combined in-camera, they worked beautifully together.

PUNCHING AN IMAGE

"Punching" an image is a design technique we share with our more advanced students. We ask them to use what they know about depth of field to create a beautiful blurry background—a really spectacular one. We then ask them to put another object/subject in front of it—to "punch a hole" in the blurry reality with something that's in sharp focus. This exercise ensures that they include two tiers of graphic information in their images. It forces them to create.

How to Do It. We'll need to start with our background tier. Again, for this exercise, you'll want to make the background as blurry as possible. The bigger the blur, the better. Start by dialing in a very large aperture, then use a long focal length and set your focus point very close to your lens. Look through your viewfinder. The background should be very blurry. Move around a bit while looking through your viewfinder. You'll see those blurs change as the things that create them change positions. Find a spot where you have a great blur. If you're not well acquainted with great blurs, this may be hard at first. Just keep moving the lens around, searching out that ideal background. When you find one you really like, stop.

The next piece of the puzzle is a simple one. You need to "punch a hole" in this nice blur with something, anything. Grab a twig, a plant, a leaf, a

■ One of our most cherished students, Lew, once described the punching process as simply finding a pretty background and putting something in front of it. Yeah Lew, that works for us!

flower—anything small—and hold it in front of your lens. Remember, you already focused close to create your blur, so all you need to do is move your new subject to that focus point. Move it forward and back, closer to and farther from the lens until you hit the focus point. Now, think about how the front tier of graphic information (your twig/flower/stick) looks against its backdrop. Move both around until you are happy with how they relate to each other. Now, shoot.

Congratulations, you just "punched" your first image. You lined up two graphic tiers of information and created an image. You did not just shoot a picture of a leaf or twig, you made an image that no one else on this planet has made. You were unique, you were in control, you painted with your lens. Don't get too swelled of a head though, this is only the baby pool of design. There is so much more out there, but at least it's a start!

Top left—A great blurry background should be mildly recognizable, with simple shapes and bold colors. Here, some weeds and the background behind them proved perfect. Notice how you can make out enough detail to understand what this tier is made of, even though nothing is in focus. The feeling it imparts is a huge piece of the painting puzzle. If your blurs aren't up to par, keep trying. **Top right**—To punch images, simply place something in focus in front of that blurry background. You may have to move around a bit, lining up different tiers, but it shouldn't prove too difficult. If you have to, have a friend hold something in front of your blurry background, then focus on it and snap the photo. **Bottom**—Here, we see another simple punch. The photographer created the background image (left), then simply found another graphic tier to add to it. The "subject" of the final image (right) is a branch. As your experience with painting with your lens grows, you'll find that your subject matter will get simpler, yet your images will become more complex.

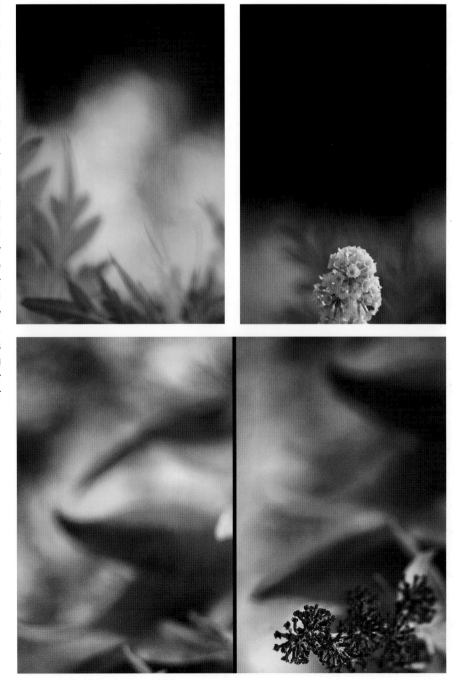

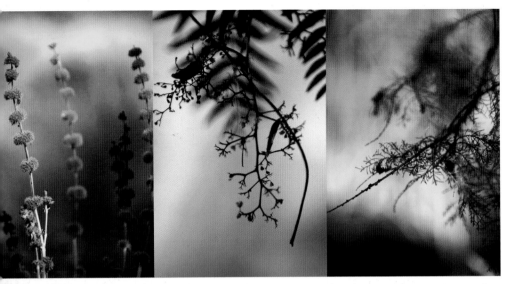

Often an artist will be attracted to color or shapes to use as his background. Selecting background elements is harder than it may seem, as extreme blur is not something the eye can see. It has to be visualized in the mind's eye. If you haven't done so yet, take some time to explore extreme blur. Get to know what the world looks like when it's blurry. This will help you recognize your paints when they're sitting right in front of you.

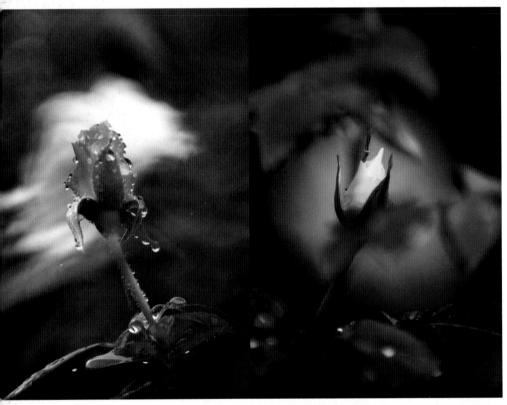

To refine your punching abilities, try to really use that background blur. Create a spotlight of sorts with a flower. Blur it to such a point that it simply becomes a shape of color. Now punch a hole in that shape with another tier of graphic information, as shown here.

Repeat the process using other subjects. Look for different backgrounds. Keep pushing yourself and your creative process. Get to where you can line up these graphic tiers of information in your sleep. Then, step back for a second, because we're going to make it even harder.

Left—Our black background images were accomplished using the punch technique. Notice how we lined up our first tier (bright flowers) with a second tier (dark, shadowed tree) to create a moody image. **Right**—Simple punches can create something spectacular out of nothing at all.

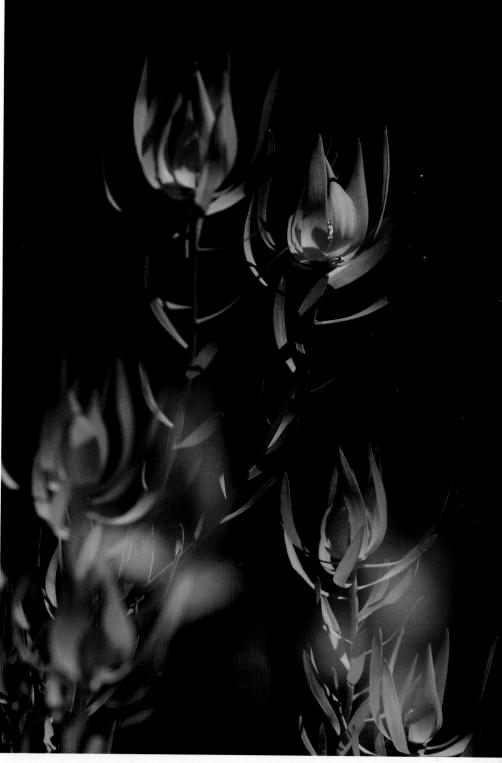

Available Punches. Once you understand the basics, you don't have to travel too far to create beautiful images. Start easy. Start near your home.

An Experiment. Head outside on a very bright day and find a location where there are multiple layers of tones and colors. Look for shadows running across the bright green grass, trees lining the horizon, etc., then find something to put in front of it.

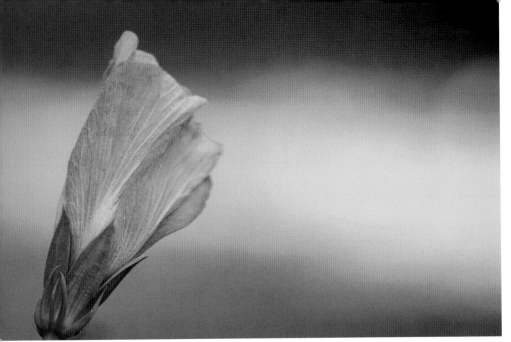

Above—Here we see three very specific areas that would make great backgrounds. The flower in the foreground will be our subject. **Top left**—With the help of a long lens (210mm) and a large aperture (f/5.6) we were able to blur the background into a smooth blend of colors behind our subject. In this image, we used the brownish-orange grass. Once blurred, it takes on a magnificent (yet simple) graduated tonal appearance. **Center**—In this image, we've used the bright green grass and the shadow. **Bottom left**—This background consists of the fence and treeline.

Left—When you look at the world with new eyes, you'll find that even a taxicab can be a significant part of the graphic puzzle. What would happen if we were to blur this taxi and then find something to put in front of it? **Right**—Combining graphic tiers is the first step toward true design. You can't control an entire image if you only shoot one subject. Once you begin stacking graphic elements (chunking them together for a real purpose) the art just has to come out.

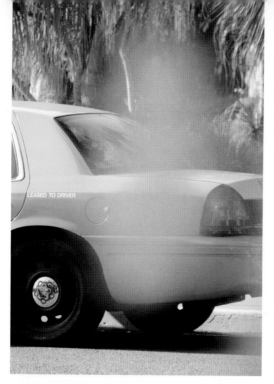

Left—Change taxicabs, and you change the available color. **Right**—Now our background is a blend of pastel colors.

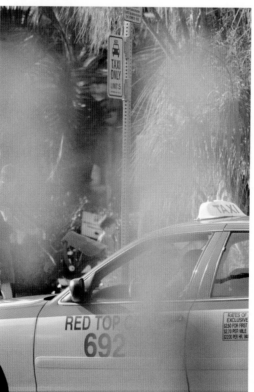 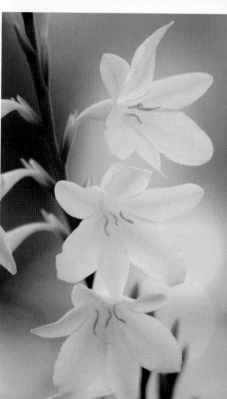

Case Study: Taxicabs and Color. A punch is created when you start with a magnificent background and simply put something striking in front of it. When you begin looking for messages made of more than one graphic tier, every piece of your image becomes important.

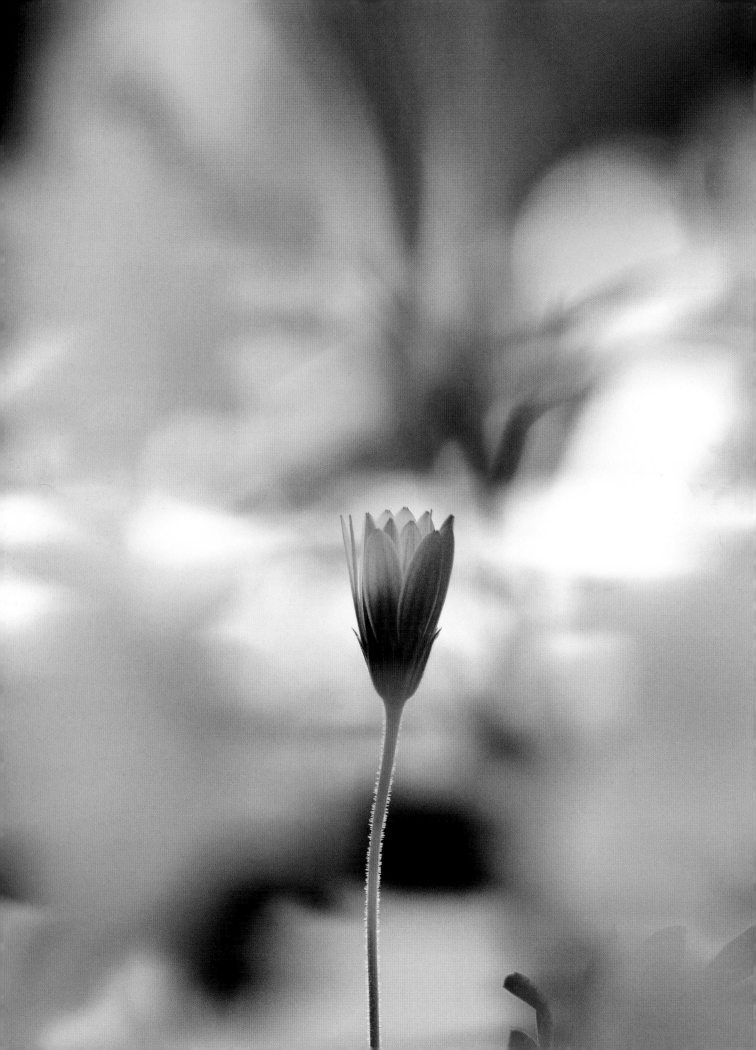

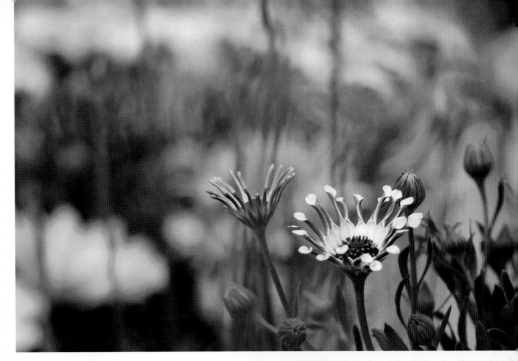

Facing page—Add one more tier of graphic information (the small flower), refocus your lens on the new tier of graphic information (which then blurs the front tier), and you've just "ripped" your first image. Yeah, this stuff only gets better! **Top**—Artists see beyond what's in front of them. They use what they know about their camera, light, and physics to create the spectacular instead of just shooting the ordinary. When ripping, you are in essence putting a photo together just as a painter does, adding graphic element after graphic element (one on top of the other) until your vision comes alive. Believe it or not, it's a lot easier this way. **Bottom**—In this ripped image, the painted quality comes from the multiple layers of graphic information (tiers) piled upon each other. Very slight movements of the camera painstakingly aligned these graphic elements. There is nothing easy about ripping an image if you lack experience. This technique will prove tedious at first, but with time it gets easier. Again, it doesn't have a choice.

RIPPING AN IMAGE

An in-focus "punch" is defined as two tiers of graphic information placed together for an aesthetic purpose. An in-focus "rip" requires three or more tiers of graphic information. This technique is tough and requires some serious out-of-the-box thinking.

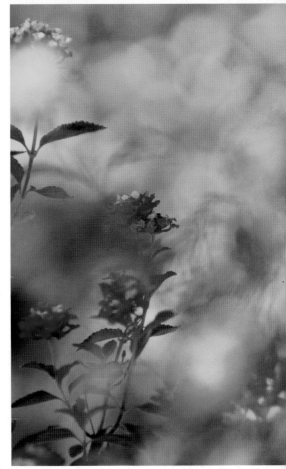

To visualize a ripped image, imagine that you are holding a piece of paper in front of your eyes. Because the paper is right in front of you, any objects behind it are not visible to you. Now, imagine tearing the paper right down the center. The single piece of paper is now two elements, and you can see whatever it is that lies in the background between those two pieces of paper in your hands.

When you undertake this technique, you can include as many tiers of information as you like. The more tiers you have, the more complex the rip you'll achieve. Bear in mind your aesthetic purpose when creating an image like this. If you don't control this technique, you'll simply create an image that appears to be a snapshot. Be precise in your intentions. Think. Visualize what you will create before you create it.

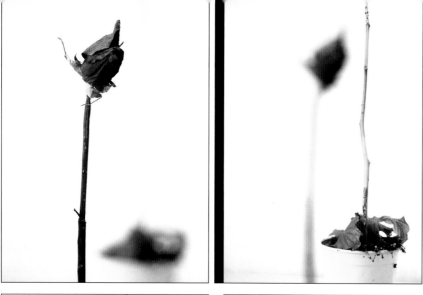

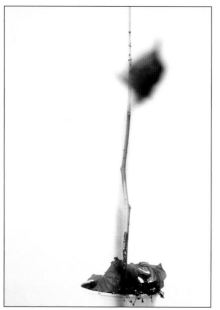

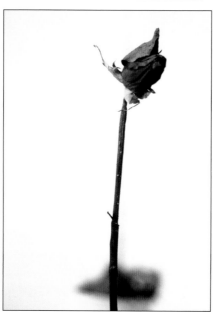

Left—In the first image, we have two graphic elements, positioned several feet apart. Notice how the available depth of field reaches only around our first subject. **Right**—In this image, the focus point was shifted to the back graphic element, and the foreground tier blurred completely.

Left and center—The third and fourth images show how, when you line up the two elements, both will blur as the focus is shifted from one to the other. **Right**—In the fifth image in the series, you can see that if you were to focus between the two elements, both would blur (and become more in focus) at the same time, creating a spatial distortion that somewhat resembles a paint stroke. This is the same aberration that you've seen in previous exercises.

Allow yourself plenty of time to master this technique. It will change how you see the world, and it will be one of the most spectacular techniques you've ever used.

Using Spatial Distortions to Your Advantage. When using the ripping technique, you may occasionally notice a stunningly beautiful "wiggle"— a paint-stroke-like aberration in your image.

As we learned in chapter 1, when you take away light, more things come into focus. For instance, when we reduce the size of the aperture, we get greater depth of field in our image. Now, let's use this rationale to help us understand the aberration: When two blurred tiers unite, they take away light. Since the two tiers are not exactly the same shape or size, this in-focus portion

is very small and not very clear. The in-focus area simply runs alongside the two blurred graphic elements, giving us what appears to be a paint stroke.

To control the paint stroke, line up the tiers with purpose. When you know what to expect, you can use the aberration to create dramatic paintings of your own.

A Hands-On Illustration. Any lens can create spatial distortions—it's just that some lenses make the effect easier to accomplish than others. A 70–200mm lens is recommended.

Place two vertical pieces of graphic information on your outdoor shooting table, one in front of the other and about four feet apart. Make sure that the background beyond the graphic elements is flat. (We used the wall of our house, as it's easier to see the effect this way.)

Stand a few feet from the first tier and line up the tiers in your viewfinder. Focus on the first tier, then the back. Slowly begin changing your focus point, moving it between the two. You will see the painted effect in your viewfinder. If nothing happens, your depth of field is too great. Use a longer length lens, a larger aperture, or get closer to the first tier to increase the blur, and try it again.

How to Do It. A rip is much more difficult than a punch, as it requires you to find and line up multiple tiers of graphic information. Building up this kind of vision will take a while, and your first few attempts may seem more like hunting and fishing than anything else. Here's a suggestion:

Find a bush with a lot of small stems, leaves, or flowers. The smaller the stems, leaves, or flowers, the better. Choose a very long focal length, as maximum blur in the beginning will make things a little simpler. Dial-in your largest aperture, choose a shutter speed within your "safety zone," and make

Left—Here, you can see that by combining more than one vertical graphic element at each of the tiers, you can increase the number of paint strokes available. **Center**—Notice how the addition of the colorful flowers lent even more color to the painted image. **Right**—Add another graphic tier in the middle, adjust your focus, and voilà—a painted image.

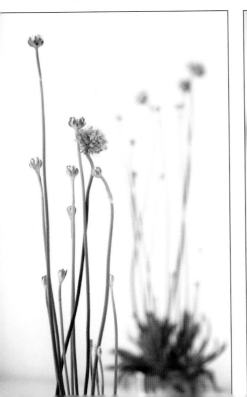

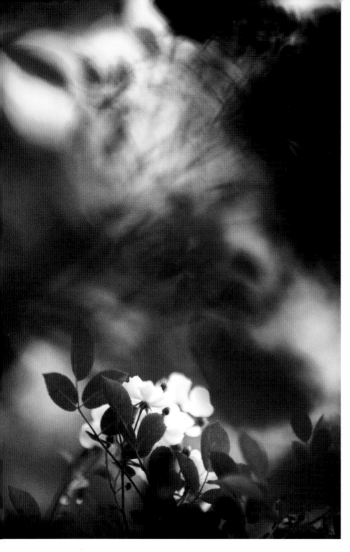
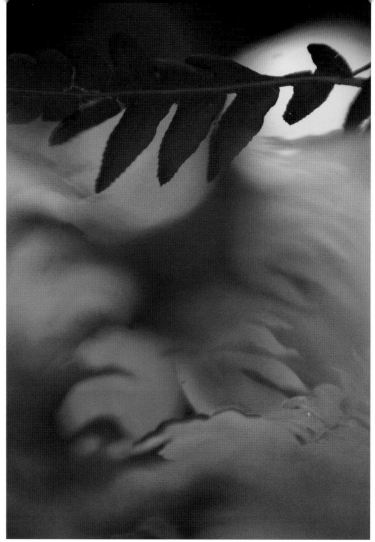

shade, so whilst/s are finish/white balance are in line with how you're feel-
ing. Here is this is done at home (below) and in the field (facing page).

Set your focus point on your minimum focus distance. Slowly push your
lens into the bush while looking through the viewfinder. Watch as the graphic
tiers of information move past your focus point. Look closely at how they
blur both in front of and beyond that focus point. Try placing your focus
point on one small object while maintaining blur both in front of and behind
it. Now, ever so slowly, move around a bit. Make a slight adjustment to the
focus point or focal length if you wish. Try to line up all three elements—the
foreground blurs, the background blurs, and your sharply in-focus subject,
whatever that might be. Look carefully at the blurs and the focus. Think,
look, see. Now shoot.

Examine the image like you've never examined a picture before. Look
closely at your subject and the overall design. Think about the color, the
contrast, and the saturation, then make some serious decisions as to how
they should be changed. Change the settings and shoot it again. Repeat the
process, this time looking for different designs. Spend some time doing this.
The more practice you garner, the better your results will be.

Left—Concentration is key. Look not only at the background and your subject, but also at the tiers of graphic information nearest the lens. You'll use these blurs to create the painted strokes you see in the image. Don't worry, once you do it correctly, you'll see the results in the viewfinder before you take the picture. **Right**—Don't be fooled into thinking this is a punch. The soft curves of color on the bottom of the above image were actually graphic tiers very near the lens. The red colors were behind the center tier. Ripping pulls out the beauty of color, lines, shapes, and patterns—the very soul of an image. **Facing page**—Sometimes you just need to hunt for the painting. We often ask our students (who seem to have trouble with ripping) to shove their longest lens into a bush, look through their viewfinder, and start changing the focus point. "You never know what will show up," we offer.

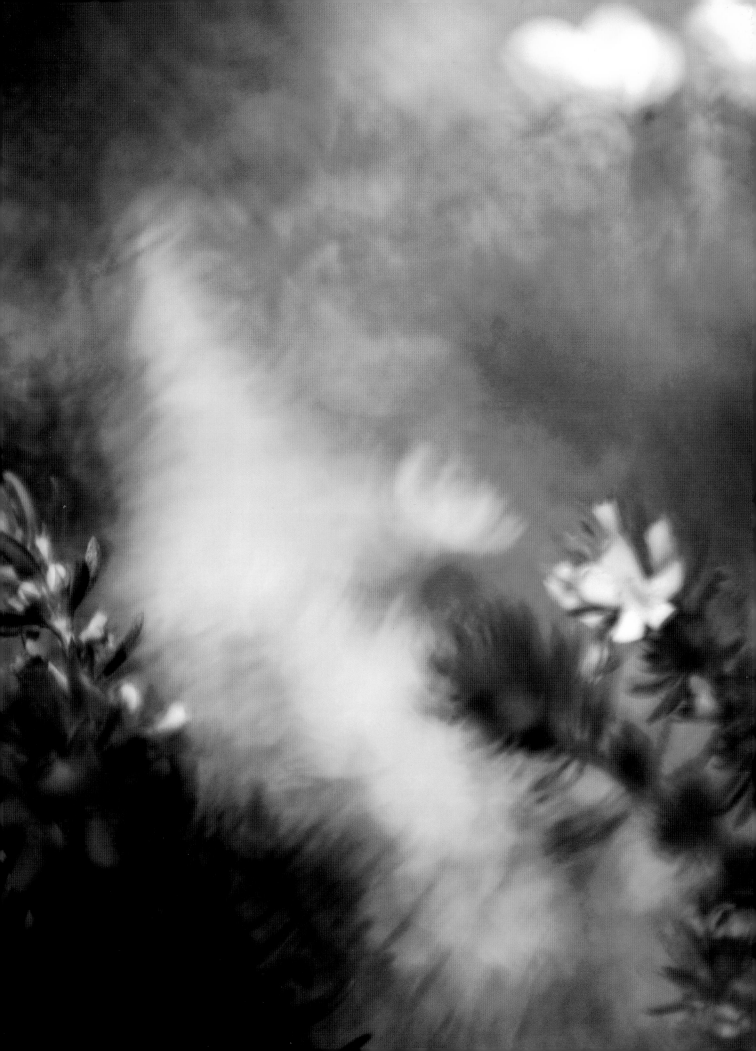

Left—Tiers collide in this image, producing a photograph with a real painterly quality. **Top and bottom right**—Start with close-up images, as the blur will be more intense. Look into the heart of the visual rhythm and explore your creative edge. Don't just shoot a flower, create a work of art.

It's best when learning to "rip" an image to keep things controlled. Here is an easy-to-follow path that boasts fun, colorful, amazing results—right in your backyard.

Left—Before you can create a great painting, you need to get your paints ready. With one trip to a local nursery, we were prepared. We bought a variety of colorful plants—short ones, tall ones, large groups, and singular buds—for this series of images. We placed them on our shooting table and began stacking them at various heights (this would later be adjusted to taste). **Center**—I used a longer lens (a 70–210mm) to help produce the necessary shallow depth of field. **Right**—Like a painter, I began with my background colors. I placed the largest group of flowers at the back of the table. These would eventually provide my base colors and shapes.

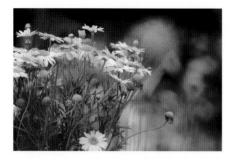 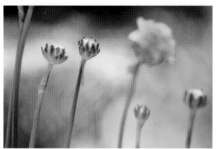 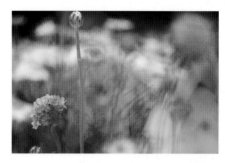

Left—I began stacking plants, one in front of the other, building a tapestry of color. I stepped back, zoomed in, and started shooting. By focusing on the flower and blurring the background and foreground tiers, I was able to create something quite stunning. However, I had only just gotten started. I wanted more. **Center**—Again, I changed my focus point, moving it a bit closer to the camera and BAM, that large pink group of flowers blended into a soft blanket of color for my plants to sit in front of. **Right**—As I moved my focus point even closer to the camera and adjusted my shooting angle, some very obvious spatial distortions occurred. These little areas of focus resemble paint strokes. The best part is, when you can predict the effect, you can control the results.

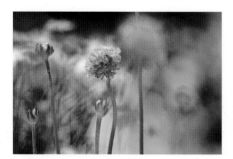 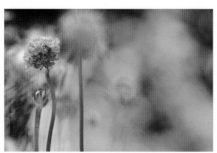 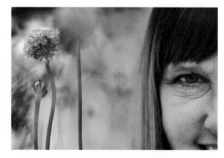

Left—As we moved the focus point farther back, more aberrations occurred, adding drama and producing the sought-after painted effect. **Center**—For this image, we recomposed the shot a bit, allowing for a large "dead" area in the scene (the right half of the image). The image begged for something more. **Right**—I finally ushered my tier of graphic information into the frame and asked her to smile and say cheese.

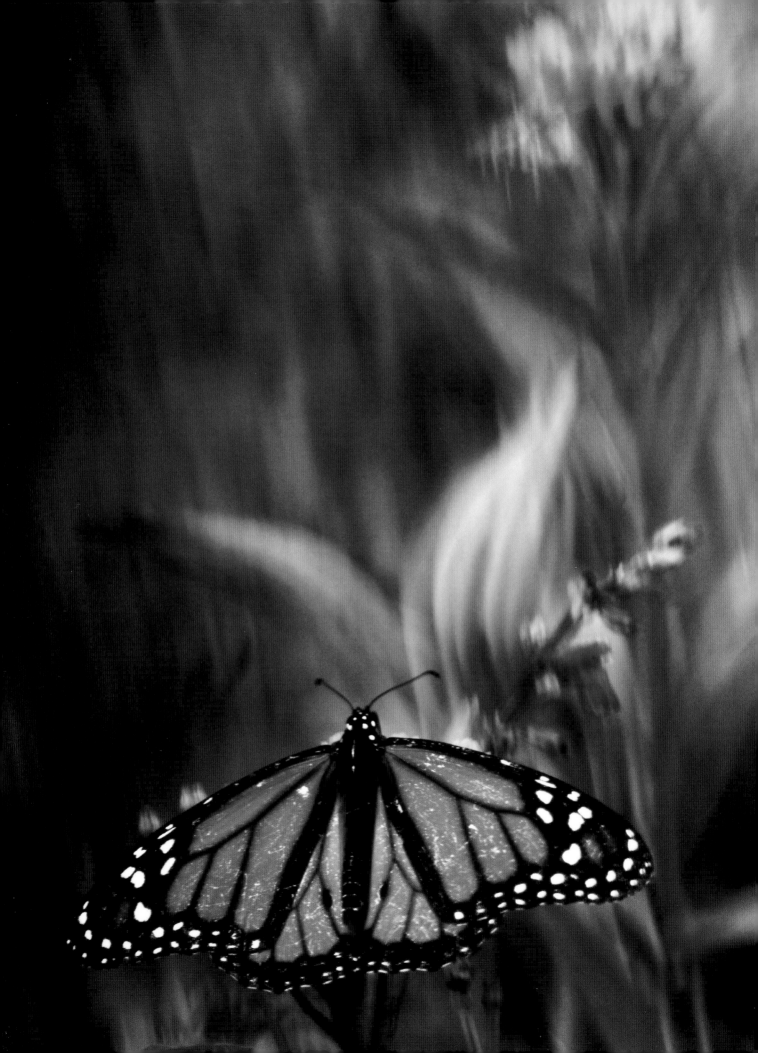

Facing page—Here, the finger painting technique was used to create the rhythm that runs through the background. **Left**—By moving your fingers vertically in front of your lens, you can adjust the angle of the finger-painted "strokes." **Right**—Adjusting the white balance, contrast, saturation, and hue during finger painting really does produce images that appear more painted than captured.

FINGER PAINTING

Finger painting is a form of ripping in which you use your fingers as the blurred foreground element. It's a bit more difficult to pull off than a simple rip, but with a little concentration (and the right lens and aperture), you should have no problem.

To create a finger-painted image, grab your longest focal length lens (or zoom in as much as possible with your current lens). Set the aperture to the largest setting. Look though the eyepiece and set your focus point a few feet away. Don't focus on a subject yet, just adjust your focus point. Take note of how blurry the background is. If it's not that blurry, move and find a background that is farther away. You'll need to keep some distance between your focal point and the background for this technique to work. Put your fingers in front of the lens. Close your fingers until you see nothing (black). Now, very slowly begin opening your fingers, allowing only a small bit of light through. Look closely at the background. The aberration in front of you, while still blurry, is in no way the same blur that you saw before. It's changed. It appears more painted than before. The focus area spills across the scene, mimicking the direction of the slits between your fingers. Rotate your fingers around the lens and you'll see the background aberrations shift dramatically, mimicking the direction your fingers are pointing. Now, with your lens zoomed out, a large aperture selected, and your fingers ready, find a flower, stick, or twig to focus on—then shoot.

You'll quickly discover that finger painting requires a lot of light. You'll need to slow your shutter speed quite a bit as your fingers are actually hiding light. Continue practicing with different subjects and different backgrounds.

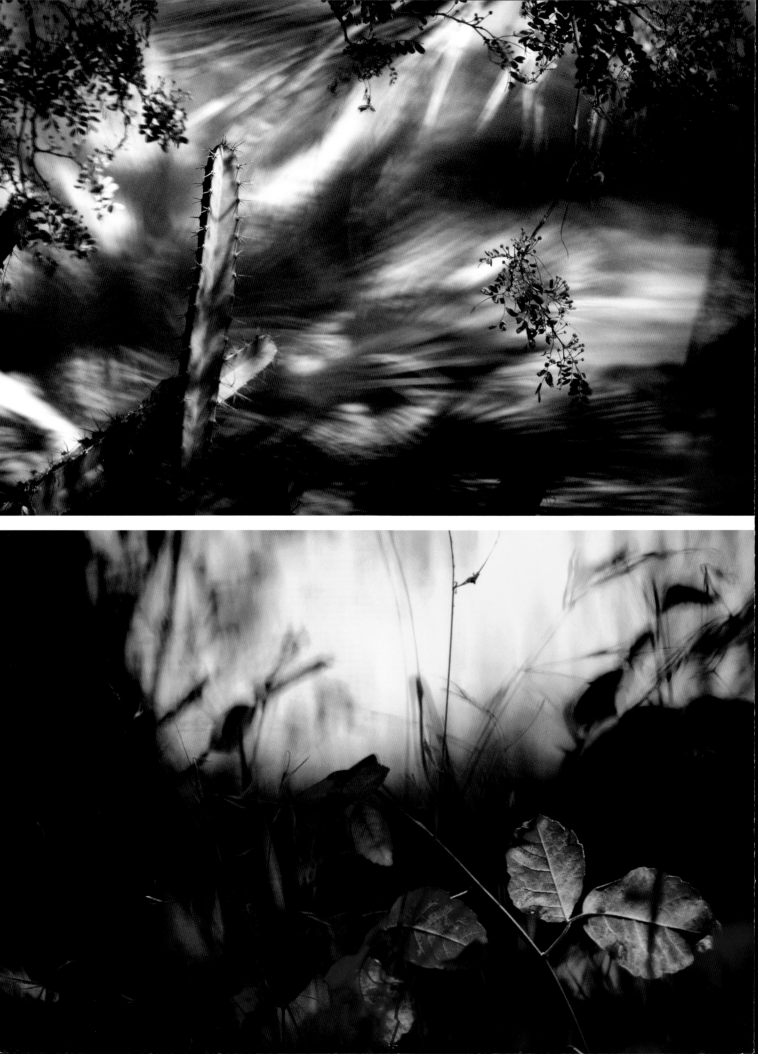

Facing page—*Top:* In this finger-painted image, the horizontal direction of the open fingers produced horizontal strokes that ran throughout the image. *Bottom:* The vertical strokes in this image were the result of the photographer placing his fingers vertically in front of his lens.

You'll discover that finger painting is an awesome technique for creating one-of-a-kind images.

Something to Watch For. Since you're putting something right in front of your lens and that something is thick (as most fingers are), you'll need to be aware that light may bounce from the sides of your fingers and enter the lens. If that happens, then the color of your fingers will wash over your image, giving the image a brownish/pinkish shine. To avoid the problem, make sure that your fingers and lens front are in the shade, never in bright light.

A Walk-Through. Finger painting is nothing more than ripping an image with your fingers. Just as in normal ripping, your fingers take away light. This reduction creates more focus areas that run alongside the graphic elements that create it.

 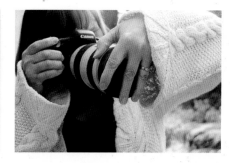

Left—Robin has lined up three tiers of graphic information. The first tier is Robin's fingers. The second tier is the plant that will be the subject in the image—and will appear in focus. The third and final tier is the tall plant. **Center**—The tall plant in the back of the image is critical to the overall photo. Since it has many long, vertical stems, the resulting finger painting will have very vertical paint strokes. **Right**—There is no perfect position for your fingers when finger painting. Slight shifts of your fingers or placing them in various directions will result in very different images.

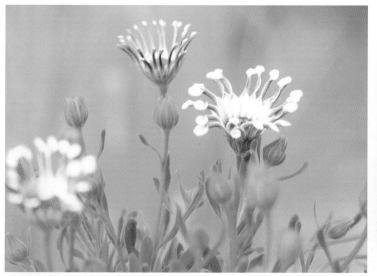 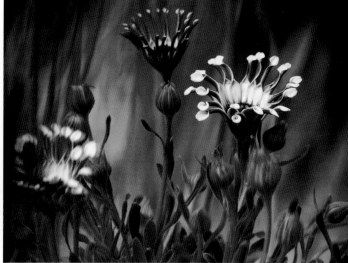

Left—When finger painting, you'll need more light than usual. This image shows the illumination needed to make up for the light that finger painting takes away. **Right**—This is the final image. Look closely at the spatial distortion in the flower on the left. Simply moving a finger in front of where the flower appeared in the viewfinder (right on top of it) created this. Make sure that you don't cover with your fingers any image area that you want to appear clear.

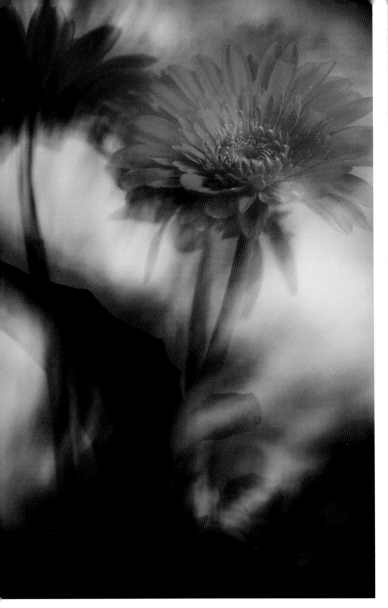

Top left—You can always combine various painting-with-a-lens approaches. Here we see the result of an in-camera multiple-exposure rip using an off-camera flash. *(Note:* Not all digital cameras offer a multiple-exposure mode.) **Bottom left**—Here is what the scene looked like. **Top right**—Here is an in-camera, double-exposure rip.

5. CONTROLLING BLUR

■ Part of the draw of being in total control of your image lies not only in determining what will be in focus but what will appear out of focus. Blur is just as important as sharp focus. It's where all the magic happens. Isolation comes from blur, and a sense of movement, rhythm, and directional flow stem from its use. Blur makes our images sing and helps us make art happen. It is a valid choice, and we need to view it that way.

As a society, we're not accustomed to using blur to express a thought or feeling. As a result, when we encounter blur in our images, we tend to view it as a problem. In truth, blur can be a beautiful thing. It's actually one of the most powerful compositional tools an artist has. As an artist with a camera, as a painter with light, you must master its use. Nothing says "brush stroke" better than a good blur.

PHYSICAL BLURS

In the previous chapter, we discussed depth of field. As it turns out, determining the depth of field we would like to see in our image is a critical first step in the image-creation process. It guides our aperture selection, the focal length we choose to shoot at, and the focus points in the image. With some practice, controlling the depth of field in an image and the resulting blurs (both in front of and behind your focus point) will become second nature. Once it is, you will be able to freely use it to your advantage to create a host of interesting blurred image effects.

BOKEH: AN EXPERIMENT

Bokeh (or boke) is the Japanese word for blur. Photographers use the term to describe the out-of-focus quality of lenses. Not all lenses produce the same amount of blur when used at similar focal lengths—even when the same aperture and focus point are selected. If you haven't done it yet, check out your

Right—The blur in this image (both in front of and behind the focus point) was made possible through the use of depth of field control. The photographer simply pre-focused his longer lens on home plate, checked his depth of field with his depth of field preview button (making sure he had at least two feet of focus), adjusted his aperture, then lined up the tiers of graphic information to tell the story (putting the pitcher in the scene). When the ball hit the focus point, the photographer shot. You will also notice (if you look hard enough) that this image was shot through a chain fence. The large aperture (f/4) and longer focal length (280mm) all but eliminated the obstruction and the given spatial distortion that occurs adds a wonderful painted "Rockwell-esque" quality to the image.

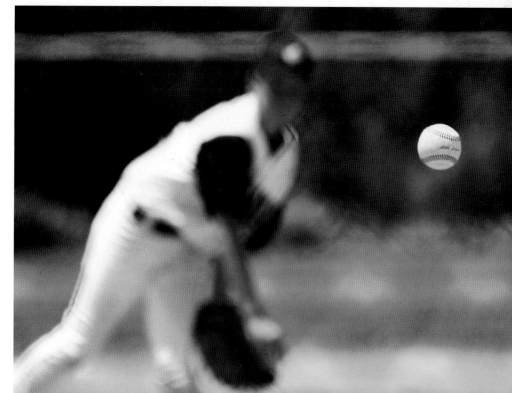

Left—Blur can quickly isolate any individual intent. It also gives the photographer the ability to truly design an image—even if the image challenges our normal conceptions. Most photographers will not shoot an image in which the bride is intentionally rendered blurry, but an artist will take that chance. They do it all the time. **Top right**—Different lenses offer different types of blur. It's important to understand how close you can focus, what the minimum focus distance is for your lens, and what type of blur it offers, both in front of and behind your focus point. A 500mm mirrored lens produced the "painted" blur you see in this image. **Bottom right**—Blur can be used to isolate your subject and wrap it in a blanket of color, tones, and meaning. Get to know what each lens you own affords, then use it well. Here, again, we see the "circled" blur effect that a mirrored 500mm lens offers. The "circles" stem from the construction of the lens itself. The blur you see is taking the shape of the mirror found in the lens.

Right—Depth of field control proved vital in both of these images. In the top photo, a precise depth of field was chosen to keep the bride and groom in focus while blurring everyone else. In the bottom image, a shallower depth of field was dialed-in to blur the bridesmaids in the background.

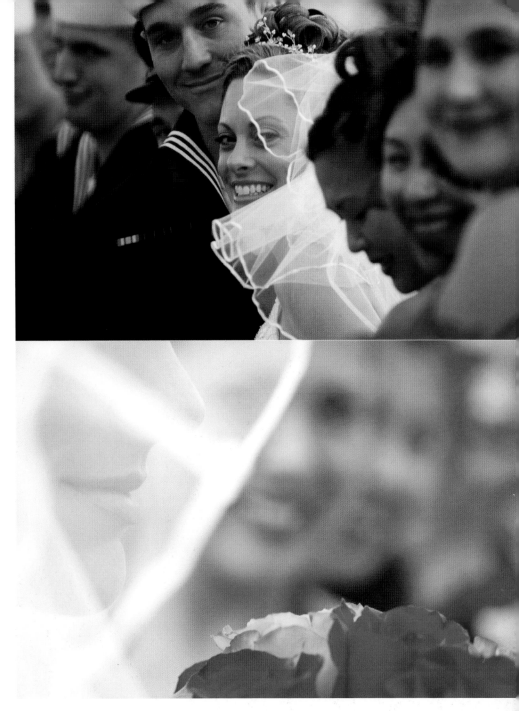

own lens's maximum "bokeh." If you're going to be proficient with your paintbrushes, you have to know what they're capable of.

How to Do It. While in manual focus, rotate the focus ring of your lens to its minimum focus distance (i.e., as close as your lens will let you focus). Choose the largest aperture your lens offers and, if your lens is a zoom, zoom all of the way out. Find a small subject with a background that is uncluttered and far away, put your camera up to your eye, and move your body (camera included) forward and back toward your small subject (or away from it) until it falls into focus. Take a photo if you like. Look at the LCD and examine that background. Really look at the blur you've got. Analyze it. Make sure that

you see just how shallow your depth of field is. What you're looking at now (behind and in front of your small subject) is your maximum blur (bokeh). This is the greatest physical blur this particular lens can achieve. Now, repeat the exercise with each lens you own.

WHAT YOU GAIN

When you start thinking about blur and controlling it, your pictures will change. They'll become more controlled, better designed, and more artfully composed. You'll stop worrying so much about simple subjects and their appearance in the frame and start being concerned with how that blur looks in your image. Eventually, you'll do what you can to improve it. (Imagine being more worried about the blur in your image than the "stuff" that's in focus. Crazy, huh?)

Once you've got it figured out, amazing things will happen. Take, for instance, an image of something nearly impossible to catch with your camera or lens set to auto. How about a picture of a bee in flight? Sound tough? It's actually quite simple.

DEPTH OF FIELD CONTROL: AN EXPERIMENT

If you're struggling with depth of field control, try this simple exercise.

Grab a water bottle and your favorite lens. Dial-in your largest aperture, turn your focus ring to its minimum focus distance (focusing as close as you can), and move your body (and camera) forward and back until the frontmost part of the water bottle cap is in focus. You may discover (depending on your lens) that only a small portion of the cap is in focus. Adjust the aperture until the depth of field reaches across the bottle cap. Remember to check this by using your depth of field preview button. You may discover that you'll have to use a very small aperture to gain the depth of field you desire. Adjust your shutter speed and ISO accordingly and snap the picture. The water bottle cap will be in focus. Great!

Now, imagine that we replaced that water bottle cap with a flower. Using the same procedure, dial-in the required depth of field. Imagine that there are lots of bees around you (hopefully you're not allergic) and that they really like that flower. Now, wait until one of the bees flies into that depth of field and take the picture. Pow! You've got a photograph of a bee in flight!

Try that with your lens set to autofocus. We dare you.

BROKE BOKEH?

If you're having problems controlling the amount of blur in your image (or don't have enough), remember that there are two other factors (besides aperture size) that can be played with: focal length and focal point distance. Longer focal length lenses (telephotos) offer more compression (more blur)

■ If you want less blur in your image, use a wider-angle lens, choose a smaller aperture, and focus farther away. If you want more blur, use a longer focal length lens, choose a larger aperture, and focus at a point closer to the camera. Aperture size, focal length, and focal point distance all work together to give you complete control over depth of field.

Top—Capturing an image of a bee in flight is quite simple, as long as you don't use your camera's autofocus feature. It's the same as shooting a moving baseball, only smaller. Simply dial-in the appropriate depth of field, choose a shutter speed fast enough to freeze a moving bee, and pick an ISO that allows you to illuminate the image as you wish. Pre-focus on where the bees are "hanging out," wait for one to hit its mark, and snap! It's a breeze. **Bottom**—Blur was a welcome part of this image. It illustrates the mood and feel of the event better than a static approach would. Sometimes allowing an image to blur is the right thing to do.

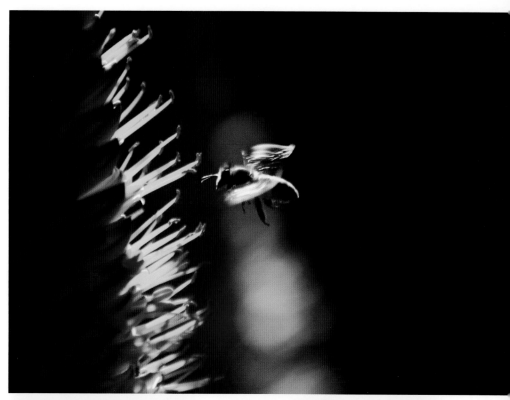

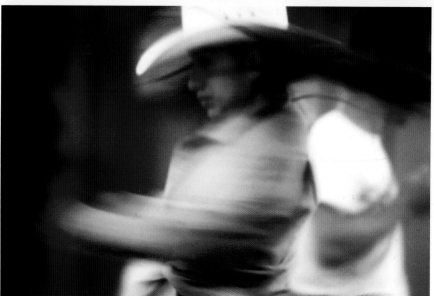

than shorter ones. (The more you zoom, the more blur you can attain.) The same works with your chosen focus point. The closer you focus, the more blur you get.

MOTION BLUR

Movement is an important part of life. We travel from place to place and we move our bodies to accomplish certain tasks. So if movement is so important to us, why do we go out of our way to freeze it in our images? Why do we run

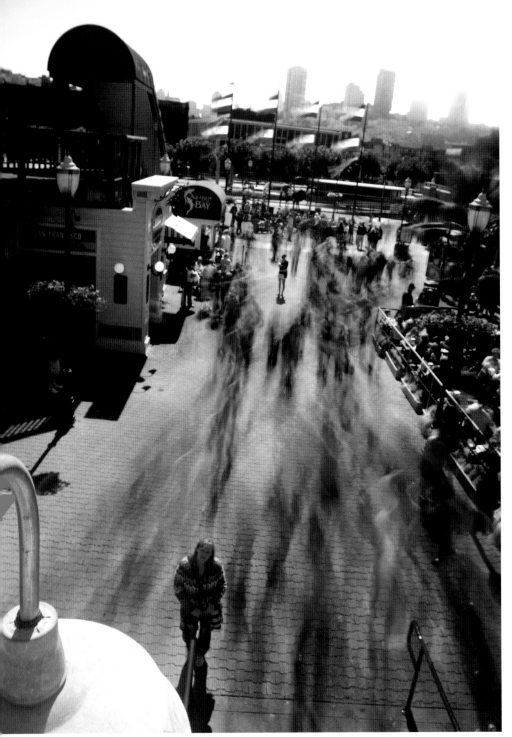

Left—Here, a very slow shutter speed was used to produce a rather startling representation of a scene that in no way resembled reality. As evidenced in the photo, only two people were standing still during the exposure. Since the shutter was allowed to stay open, anything within the frame that was moving (everyone else) blurred dramatically. The photographer chose a 5-second exposure, the aperture was f/17, and several neutral density filters were used to cut the excess light so that the image would not appear "blown out."

■ Facts are facts: if your shutter speed is too slow, then you're going to get a blurry photo, even if you employ image stabilization or use a tripod. These tools are designed to control camera movement, not subject motion. Life moves. Be ready for it.

from the possibilities that slow shutter speeds afford, never seeing the creative expression that blur can create, never playing with its effects, never using it to express how we truly feel about life or that world that continues to swirl and move about? Why are we so afraid of blur?

The answer is simple: it's not normal.

We've all shot blurry photos before and, for the most part, they were pretty bad. Our subjects were all "out of whack" and ghostly. Instinctively,

we try to take photos of the things in front of us, frozen the way they appear. That means no blur. Since we—and our subjects—can move faster than the camera's shutter (when a slow shutter speed is selected), we sometimes unwittingly capture a blurry subject or scene. Usually, this is not a welcome sight. The fault, of course, lies with us. Our shutter speed was simply not fast enough to freeze the action.

Creating Motion Blur. There are two ways to create motion blur: you can allow the world (or subject) to move in front of your lens during a long exposure or move the lens itself and make life blurry. Shutter speed, of course, plays a huge role in the actual amount of blur that will show up. As we learned in our previous fast shutter/high ISO exercise, it's impossible to create motion blur if our shutter speed is $\frac{1}{4000}$ or $\frac{1}{8000}$. The trick is in learning how much blur the various shutter speeds allow. For that, you need to practice.

LIFE MOVES: AN EXERCISE

Let's start by exploring blur to its extreme. Find a location where there are lots of people moving about. Your goal will be to take a series of images in the bright midday sun that illustrates the power of shutter speeds—not necessarily to take pretty pictures. At first we'll freeze our subjects, and then we'll slow things down. Sound exciting? Let's play.

Stabilizing the Camera. You will need to stabilize your camera for this exercise. Tripods can be a bit awkward to carry around. They also tend to keep photographers shooting at one perspective. Of course, they can also make you a target for high-end camera thieves.

Bottom—As a society, we're not accustomed to using motion blur to express a thought or feeling. We tend to view blur as a problem, but it's actually one of the most powerful compositional tools available to us. Here, the artist took advantage of his black & white in-camera options (such as filter color, contrast, and white balance) to dial-in the mood seen here, and then used several neutral density filters to strip the light from his image. This allowed him to use an extremely slow shutter that produced the amazing cloud-like appearance of the ocean waves. This was shot at f/5.6 with an exposure time of 5 full seconds.

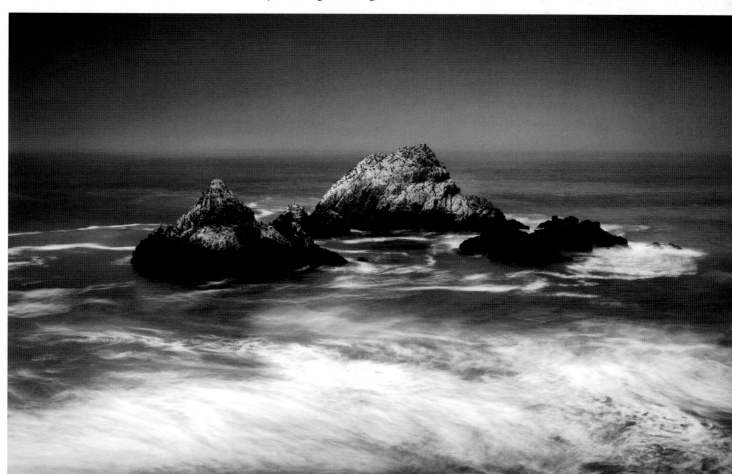

A beanbag is the perfect solution. It's small, fits easily in any camera bag or purse, and actually frees us a bit creatively. To make one, purchase a small piece of stretchy material (such as spandex or Lycra) from your local fabric store. Cut it into two 5x5-inch pieces. Sew the two squares together—inside out—leaving a small open area. Flip the bag inside out and fill it with beans (we suggest lentils). Stitch the opening closed. Use the beanbag as needed.

Creating the Images. Place your camera in a spot that offers a great and sweeping view of the area. Choose a shorter focal length lens (wide angle), low ISO setting, and a very large aperture. Find a shutter speed that makes the scene and the people appear perfectly lit. Take a few test shots if need be. (If there is a lot of contrast in the area, reduce the contrast setting in your camera. Also, be sure to choose the perfect saturation level.)

Take a few more shots and analyze the image on your LCD. The people in the scene should appear frozen. Now, play with reciprocity. Turn the aperture dial three clicks to the left, then make the appropriate adjustment (three clicks) with the shutter speed. Take another photo and examine the results.

Top—A simple 5x5-inch piece of Lycra (or any other stretchy material) filled with lentils is what we (and our students) use as a support base for our camera and lens. Tripods, while very effective at holding the camera steady, are also quite large, sometimes heavy, and don't always travel that well. A simple (and very small) beanbag goes everywhere and is rarely a problem. **Bottom**—A beanbag travels easily in any camera bag. It sets up in an instant on just about anything and will allow you to shoot as slow as you wish. Remember to use your camera's timer so that there is no camera shake. Pressing the shutter button during a long exposure will often cause unwanted camera movement.

Top—Here we see the motion blur options available when we use a very small aperture. Since a very small aperture lets very little light strike the image sensor, we can use a slow shutter speed without the fear of "overexposing" our message. The top-left image was shot at $^1/_{100}$ second. The top-right photo was shot at $^1/_{15}$ second. The bottom left-image was shot at $^1/_5$ second. The bottom-right image was shot at $^1/_2$ second. **Bottom**—At two full seconds, the moving subject is nearly invisible. At three seconds or longer, anything moving in the frame would not show up at all. This is the power of blur taken to the extreme.

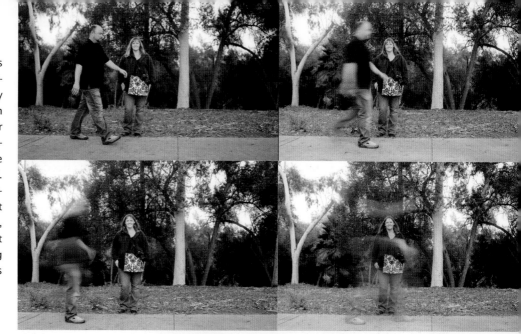

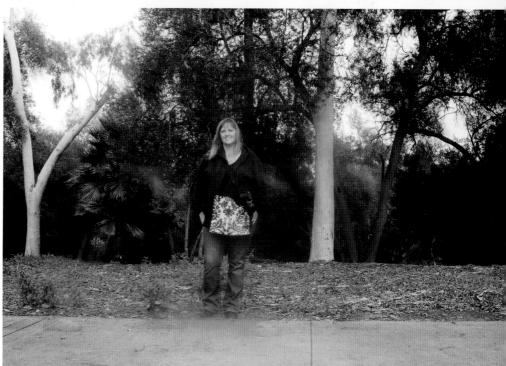

Repeat the process until you reach the smallest aperture possible using the slowest shutter speed you can without making the image too bright. Take a close look at the people in the image now. As the shutter speed slowed, their movements started to blur dramatically, yet the surrounding area (anything that wasn't moving) stayed frozen.

TAKING AWAY LIGHT

If you were to shoot in the middle of the day, you might find that there was just too much light present for you to shoot with the slower shutter speed you were hoping to use. As discussed in chapter 1, there are two ways to

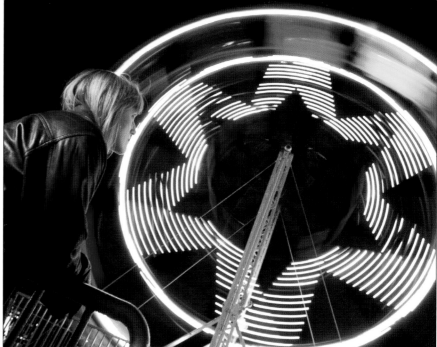

Top left—Neutral density filters screw onto your lens and cut the amount of light that enters your camera. They come in various densities and appear dark to the eye. The only problem is that, for each lens, you'll need a bunch of them, at various densities. This means that you'd be devoting a lot of valuable camera bag space to something that you probably won't use very often. **Bottom left**—Cross-polarizing is an optical "trick" that requires two linear polarizers. Stack the filters, then attach them to the front of your lens. Turn the bottom polarizer to eliminate glare from the image (that's the polarizer's job), and then rotate the top polarizer to eliminate the excess ambient light. Think of cross polarizing as an alternative to the very expensive variable neutral density filter. The only side effect you can expect (depending on the manufacturer of the filter) is you may pick up a slight discoloration when used at the extreme end of darkness. **Right**—It's fun to play, to visualize. Once you lose your need to keep things frozen, a world of options will open up to you. Blur can be fun when put to use. For most of us, though, these options are quite foreign—especially if you've been stuck in auto your whole life. So push yourself beyond the norm. Play with your camera. Shoot with slow shutter speeds on purpose, and be ready for the ride of your life.

take away excess light once you have hit your "low light" extremes in-camera (i.e., once you've dialed in your lowest ISO and smallest aperture): you can employ neutral density filters or use cross-polarization.

THE EXTREMES: MAKING PEOPLE DISAPPEAR

Try the slow shutter experiment again. This time, though, have several neutral-density filters or two linear polarizers handy. Start again with a fast shutter speed and slowly decrease the size of the aperture. Follow the rules of reciprocity, and begin slowing down your subjects. Keep slowing them down, and keep taking away light. What you end up with might shock you. Since life moves (we're all just renting space, after all) and your camera can blur a moving subject, extreme blurs offer extreme consequences. Eventually, your subject will blur to such a point that it won't appear in the frame at all. It will simply disappear.

PARTIAL BLURS

Try this: Have your subject catch or toss a ball. Watch closely as you create the image. Try to isolate the specific shutter speed required to blur just the subject's moving hands while keeping the other parts of their body in focus. This knowledge will become very helpful later.

PANNING

Most magazines want you to believe you should only use this slow-shutter technique with cheetahs, but the truth is, panning can be done with

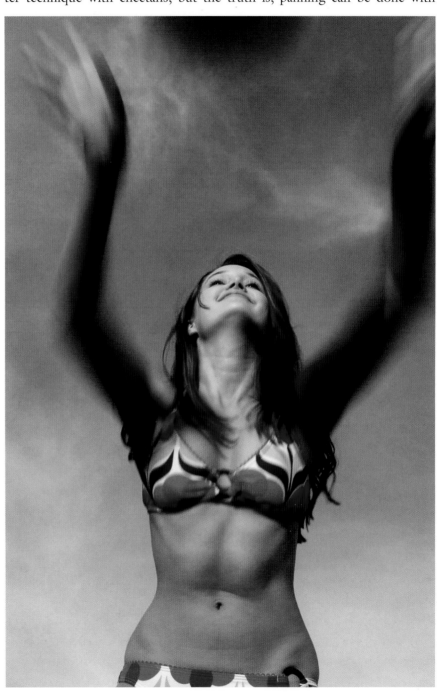

■ If art really is about thinking outside the box, about visualizing something that doesn't exist, then making people disappear is about as extreme as you can get. Remember, painting with a lens is about visualization. Just because you can't see something doesn't mean it can't be created with a camera.

Right—Thanks to this experiment, we learned that $1/50$ second was not fast enough to freeze our model's hands but was perfectly fine for the rest of her body.

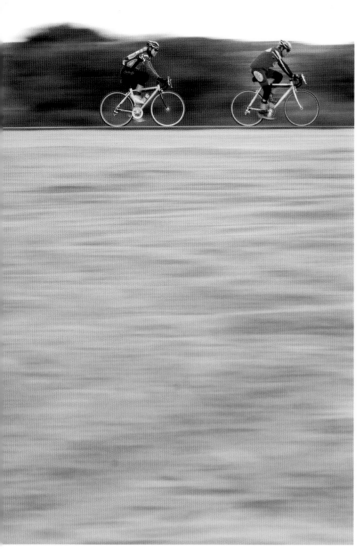

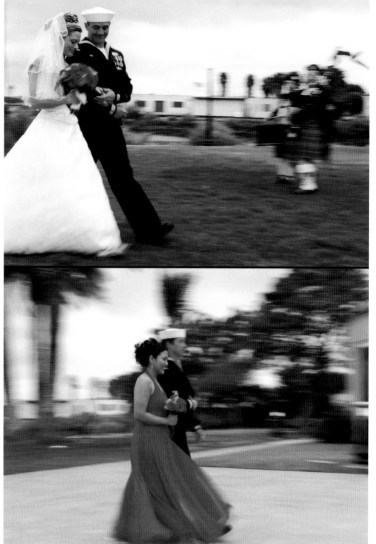

almost any subject, as long as it's moving. Panning can also teach you a lot about movement and what you can expect when you use your camera to the extreme.

The Settings. After years of teaching this technique to students, we've discovered that a shutter speed of $\frac{1}{15}$ is best for the beginner. It's neither too fast nor too slow and offers you the best chance at early success. Your aperture and ISO setting will be whatever it takes to make your image perfectly lit. So, simply dial-in $\frac{1}{15}$ second for your shutter speed and then adjust your aperture and ISO accordingly. Get a perfectly lit image.

What to Shoot. Make it easy on yourself at first. While many people want to start with their pets (cats, dogs, and horses), keep in mind that every part of the animal (when it moves) is usually moving in a different direction. This makes panning (for a beginner) tough, to say the least. We suggest something that moves in a more controlled manner and in one direction: like a bicyclist, a car, or a child on a skateboard.

How to Do It. Position your body so that you are facing the place where your subject will be when you fire off the first frame. It's easiest to pan when the subject is moving directly in front of and parallel to you, from one

Left—Panning is an art form in and of itself, and achieving perfect results will require a lot of practice. Do yourself a favor: when learning this skill, practice on subjects moving very smoothly. As shown here, bicyclists can make perfect subjects. *Right*—Panning at a wedding is an easy way to isolate the bride and groom or any other member of the wedding party.

corner to the other. Pre-focus your lens on the spot your subject will be when it passes directly in front of you, then turn either right or left and point your camera at your subject. Don't move your whole body, move only your torso. With your feet firmly planted and pointed directly at the road, twist your upper body toward your subject as they begin their "run" in front of you. Follow the subject's movements closely with your camera. The trick is to keep your subject in the same spot of your frame throughout the entire shooting process. *Tip:* If you're photographing a moving person or animal, concentrate on just one body part. If you want their head in focus, than stare at that throughout the pan. The part of your subject that you concentrate on will always be the most in-focus part of your pan.

Be sure to trace your subject's movements exactly with your camera. We recommend keeping both eyes open when you pan, since at some point during the exposure the viewfinder will go black. This way you can still move the camera accordingly should your subject move from its forecasted path. (This happens a lot when panning with kids or animals at slower than $^1/_{15}$ second shutter speeds.)

When your subject hits its mark, when it's directly in front of you and your body is not twisted, depress the shutter but *don't* stop moving. For a pan to work, follow-through must be perfect. At first, you may find yourself stopping when you shoot. This is to be expected; it's how we've been trained to shoot (always holding the camera steady). But this is different. You have to move to make this technique work.

Inverse Panning. Imagine for a moment sitting atop an enormous Lazy Susan (it's a serving dish that spins). Now, picture your camera sitting a few feet from you on this Lazy Susan, aimed and focused on you. The timer is set and the Lazy Susan is spun—with both you and your camera going for a ride. During the spin, your camera's timer reaches its mark and shoots the picture. You were working with a small aperture, so you selected a slow shutter speed. What would the image look like?

■ Remember, when panning, you're only trying to isolate a subject using a blurry background—not necessarily render your subject completely in focus. This is important to remember, as you can easily find yourself overwhelmed and disheartened in the beginning. This technique can be tough to master.

Right—An inverse pan allows you to really be part of the movement; it actually requires it. In this image, the photographer and models all joined in on the fun. Since they were all going the same speed (as far as the camera was concerned), they were all frozen, yet the background (which was moving quite a bit) was rendered very blurry.

If you said anything other than "you would be in focus and the background would be blurry," you would be wrong. Since you and the camera (as far as the camera is concerned) are not moving at all (you're both moving in the same direction at the same rate of speed), you would both be frozen. The background, however, would be quite blurry as, compared to the camera and you, it would be moving very fast. Hence, your image would contain a crisp version of yourself and a very blurry background due to the apparent motion of the background (not necessarily yours).

ADVANCED BLUR OPTIONS

When you begin to recognize the creative advantages that incorporating blur in your images offers, you will find that there are other ways to create the effect. You could really push the envelope of creativity and play with some basic physics as well.

Picture yourself ice skating with eleven of your friends. You all link hands and form a line. You are the first in line. You begin to slowly skate in a tight circle. The skater next to you complies, only his journey is twice as far. The skater next to him does this same, except he needs to skate a bit faster and farther. The skater next to him begins to worry. By the time you hit skater number twelve, he is skating so hard and so fast that you can only hope he makes it. Of course, you are still moving only slightly.

The same idea can be applied to shooting with a camera. The camera itself can move—it's just a small box after all. You can slowly spin the camera while employing a slower shutter speed if you want. Of course, few people try such

Below—Spinning the camera creates a wonderful circular pattern of blur around your subject. This technique is a bit tricky to perform, but with enough practice you'll be spinning your way to painted images in no time.

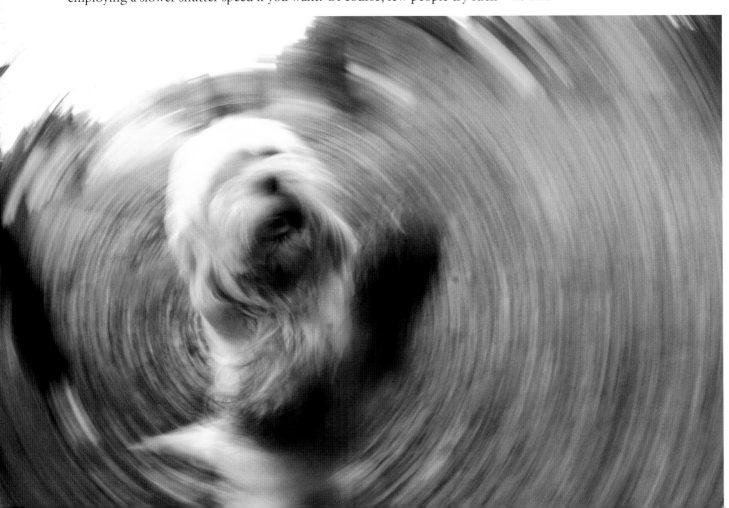

Right—As an artist, you always have a choice; you can shoot like everyone else or have some fun with your camera.

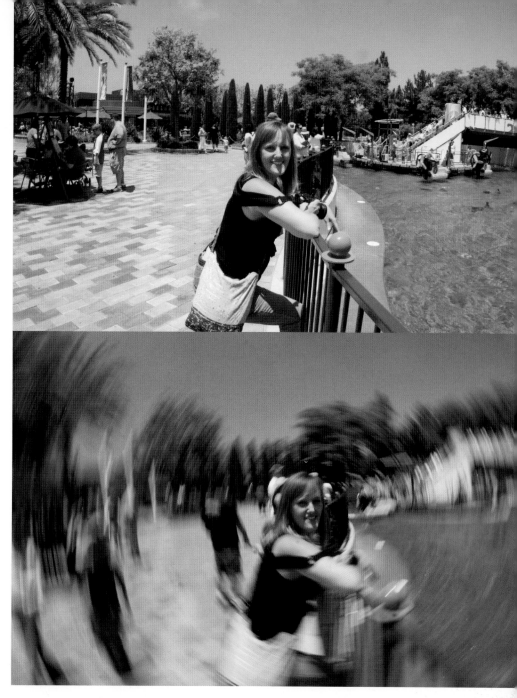

a thing, since "that's not what you do with a camera." Bear with us a bit, and we may change your mind.

The Simple Spin. This is a fun technique that all of our students have had a lot of success with. Keep in mind that this approach is way outside of the box. You should try this knowing full well that the results will not be "normal."

To begin, focus on a small subject far in the distance. Use a wide-angle lens if you have one at your disposal. Adjust your shutter speed to $^{1}/_{100}$ or $^{1}/_{125}$ second. Now, quickly but ever so carefully rotate the camera while you shoot. Many of our students find that by simply tilting their head quickly, they can get a fairly decent spin.

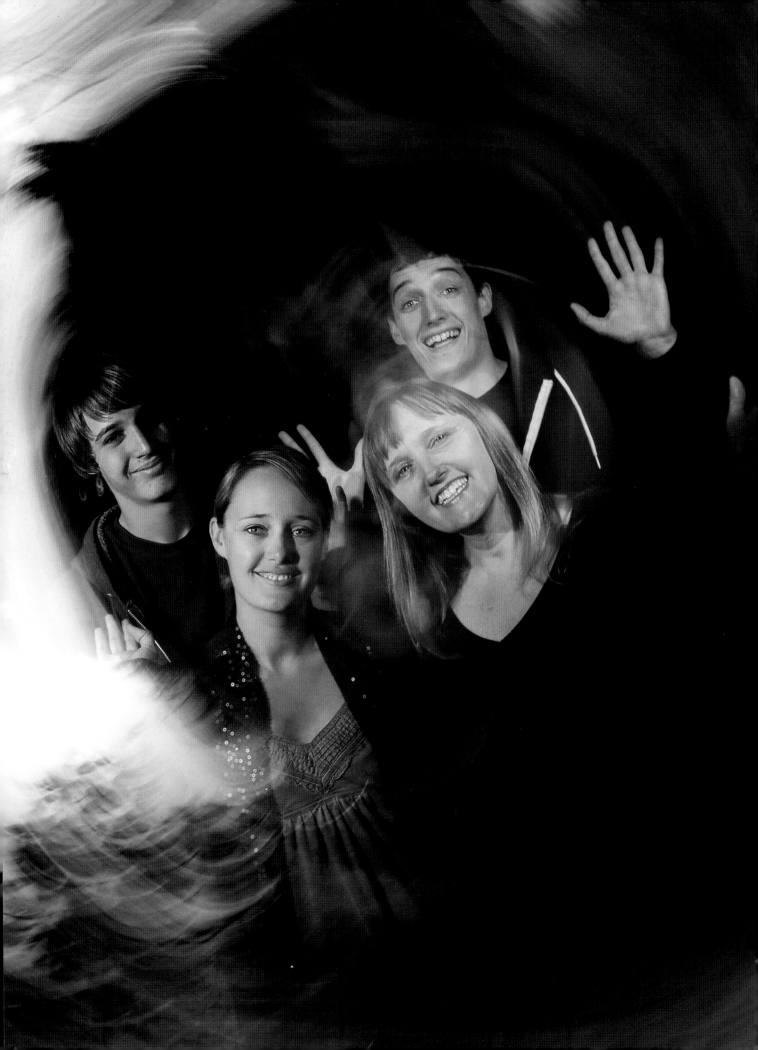

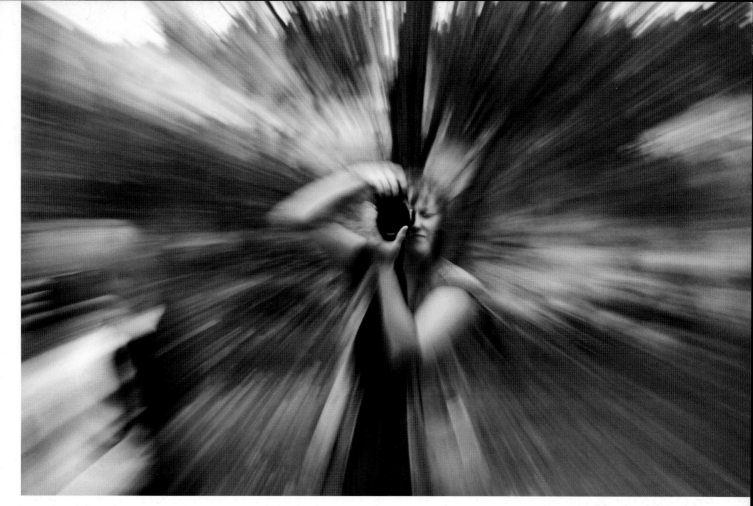

Above—Using this technique requires a simple zoom lens. The secret to a great zoom shot is to begin the zoom first and then slowly squeeze off the shot during the zoom. Too often new "painters" will try to trigger the shutter at the very same time they begin zooming. It doesn't work like that. Again, this technique is tough to master, but the results are worth the time and effort. **Facing page**—Thinking and painting outside of the box may just give your images the edge you're looking for. To play even more, we added the action-stopping power of two flashes to our camera spin. A slow shutter speed was chosen to allow the spin to affect anything lit with ambient light. The flashes (set on light stands) were fired during the exposure, freezing our models.

The Simple Zoom. This technique is even more fun than the spin. It requires pretty much the same settings used in the above exercise. This time, instead of spinning the camera, try zooming-in with your lens during your exposure. Yes, that's right: change focal lengths aggressively as you press the shutter button. Make sure you're using a zoom lens that glides easily between focal lengths; the last thing you want to do is break the lens.

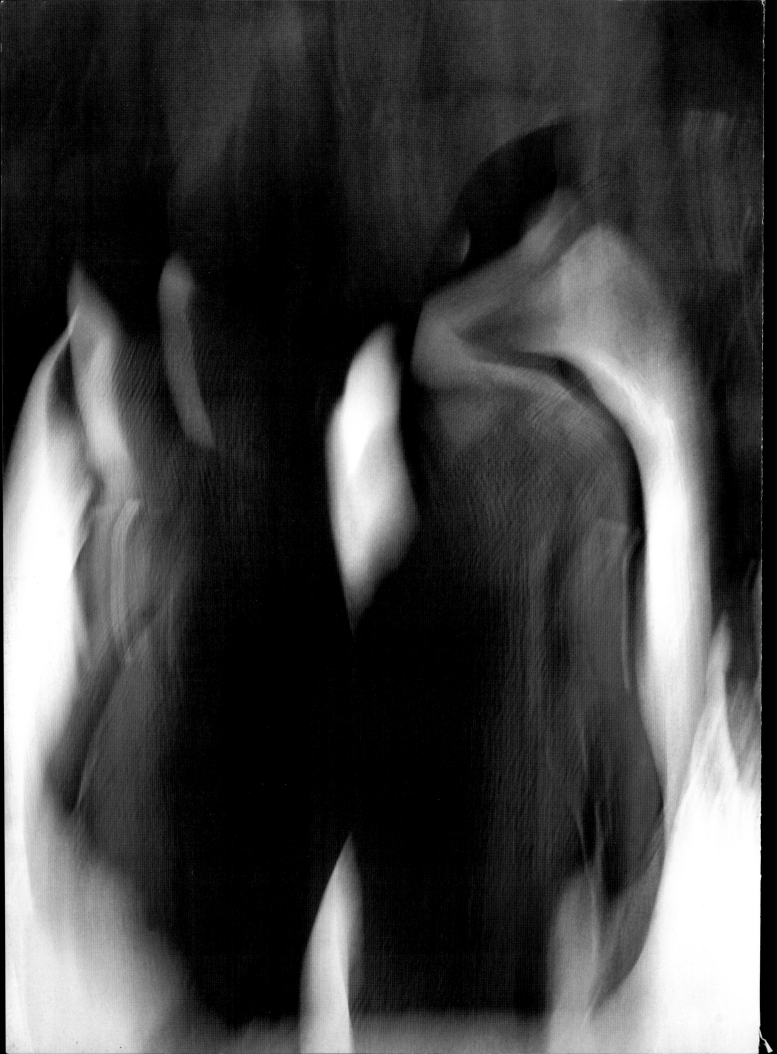

BLUR TO THE EXTREME

As you've discovered, blur provides photographers with a wide array of artistic options. The pan, spin, and zoom described earlier were all excellent examples of what can happen when you include time and movement in your message-creation process. They are pretty classic photography techniques, but these slow-shutter options are just the beginning. We can (and should) push things even farther.

If you'll recall from chapter 2, our cameras have a bulb setting. When we set our shutter speed dial to bulb, we can keep the shutter open for as long as we wish. If you thought the pan and zoom were awesome slow-shutter techniques, just wait until you see what happens when we take the brakes off.

FEELING THE LIGHT: AN EXERCISE

When shooting in the bulb mode, you'll need to learn to *feel* the light. You'll have to learn to "just know" when to let up on the shutter, based on how the light feels on the back of your neck. Obviously, if you've never tried this, it's going to be difficult. Keep in mind, though, that just because you have never done something before, doesn't mean it's impossible. You just need to have a little confidence, and practice, and get your feet wet.

Facing page—Imagine standing in front of these magnificent creatures and being the only photographer moving your camera as you shoot, creating rhythm and meaning. You can shoot on bulb, move your camera when you shoot, and create dramatic images on your own—but success will require practice. **Below**—It's all about the blur when painting on bulb. Since the exposure time can be as long as you like, you have plenty of time to add rhythm, color, and texture to your image.

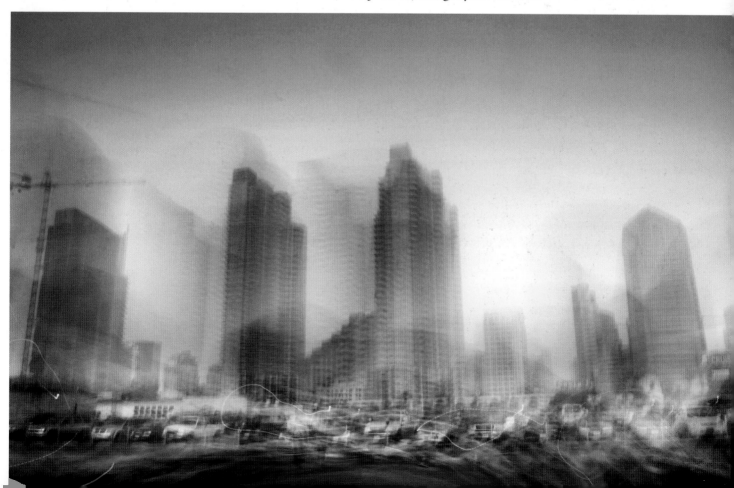

Grab a wide-angle lens and head outside in the middle of the day. Change the ISO to the lowest-possible setting. Choose the largest aperture your lens affords, focus on the world in front of you, and pick a shutter speed that gives you perfect lighting. (Your shutter speed will probably be quite fast.) Remember to make any needed adjustments to your white balance, contrast, and saturation. Now shoot.

Once you have a great image, start playing with reciprocity. Make the aperture one click smaller and the shutter speed one click slower. The amount of light used to expose the image will remain the same. Repeat the process, this time paying attention to what that shutter speed feels like in your hand. (*Note:* The small vibration in the camera and the sound you hear isn't the shutter; it's the SLR's mirror moving up and down at the beginning and end of your exposure. At high shutter speeds, the mirror slap will feel the same every time, as it can only fall so fast. When shooting at very slow shutter speeds, the mirror slap will feel more pronounced. It almost becomes a "clunk.") The shutter actually opens and closes before you feel the mirror slap, but feeling the vibration of the moving mirror will help you get an approximate feel for the length of time the shutter is open.

Keep playing with reciprocity, choosing smaller and smaller apertures and slower and slower shutter speeds. Concentrate on what those shutter speeds feel like in your hand. Concentrate on the "clunk" you hear. You will probably also notice that the slower the shutter speed you shoot at, the more motion blur occurs in your image. This is to be expected, but don't get hung up on it. The goal of this exercise is to learn to understand what certain shutter speeds "feel" like. This is not about pretty pictures—yet.

Once you've dialed-in the smallest available aperture and the slowest-possible shutter speed, take a few more images—with your eyes closed. Concentrate on the sound and feeling of the mirror moving up and down in your camera. Now, set the shutter speed to bulb and, with your eyes closed, press the shutter button, leaving it down for the exact same amount of time you just felt. Check your image. Amazingly your image will be lit very similarly. Now, for at least fifteen minutes (yes, fifteen whole minutes) walk around with this same setting, taking the exact same type of image on bulb, trying very hard to maintain the same lighting. It's important to quickly garner as much experience as possible, as doing so will inspire your confidence. If you cannot build your confidence, there is no doubt that you will fail at this.

Stepping It Up a Notch. Once you've learned how to feel the light, push yourself to look for different lighting scenarios. Move to a darker shadowed area and repeat the process. Your first image will probably be a bit darker than you would like (since there was less ambient light to begin with). Now, try to let the image "cook" a bit longer. Feel for a longer shutter speed. Slowly fine-tune your new technique. Challenge yourself with various lighting situations

■ Some people take to shooting on bulb very quickly, while others have an incredibly hard time. Free your mind and your vision. When you're practicing with this technique, expect to fail for a while. You're doing something few artists-with-cameras have mastered. Be proud of your intentions and strive for perfection. It's what makes us strong.

while shooting on bulb. For these images, it's only the exposure you should be interested in, not the focus (yet).

Repeat the process indoors as well. Get to a point where you can determine the exposure time required at this smaller aperture setting in any given situation. If you're sincere in practicing this technique, you'll be surprised at just how quickly you can pick it up.

Going Even Slower. When shooting on bulb, there will come a time when the ambient light around you will be so bright that you'll find it impossible to shoot slow enough to paint. At this point, it's time to pull out the neutral density filters or to attach two linear polarizers to your lens to cut the light (see chapter 4). Do whatever it takes to keep shooting using the bulb setting.

YOUR FIRST SWIPE

The most basic bulb painting technique is called a swipe. You literally swipe (or move) your camera from one point to another. Your first few images will look pretty bad, but remember, it's the technique we're after right now, not the images. Start small, if you like, by swiping while photographing flowers, bushes, or twigs. If you're more adventurous, try a landscape. No matter the subject, the technique is the same.

How to Do It. Start with your camera on the bulb setting. Feel the exposure time. Make sure you've got it down pat. Begin as usual, holding the camera very steady and allowing the exposure to cook through. This time, however, just an instant before you let up on the shutter, drag the camera to the right, left, up, or down. Then release the shutter. The idea is to simply "cook in" a certain amount of quasi, in-focus information and then add a bit of movement to the picture. This will be tough; so many things have to go right for this to work. Again, the more you practice, the more you fail, the better your odds will be.

If it doesn't work right away, don't give up. Try a different approach. Vary the length of time you swipe and the length of the exposure. Think of it as if

Left—The swiping concept is simple. Just drag the colors and shapes through your image. Pull light across the frame. Look closely at your image and decide if you should swipe faster or slower. Should you adjust your timing or employ a longer exposure time? There are a thousand things that could go wrong, but that's why it's so much fun. Don't give up if it doesn't work at first (it probably won't!). It's in there. It's in you. **Right**—There is nothing like the freedom offered when painting on bulb. You are literally painting with your lens, sending color and shapes sliding across your viewfinder and creating a tapestry of emotion and feeling. The original scene lacked flavor. It was just a boat on a dock.

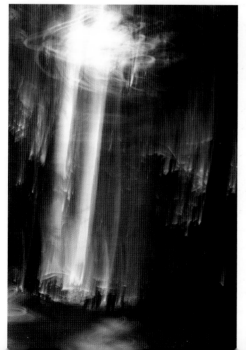

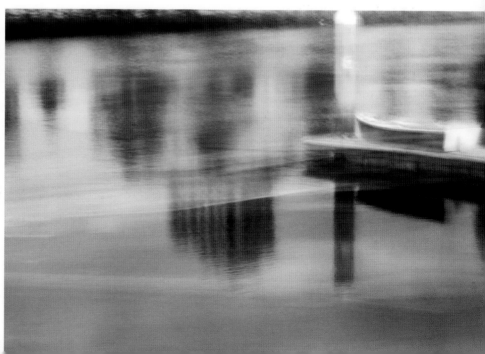

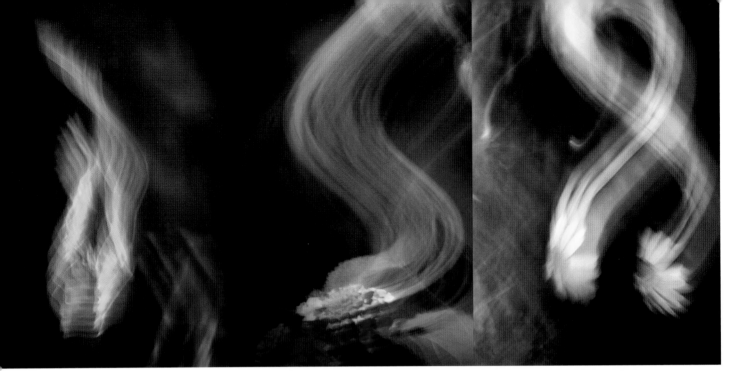

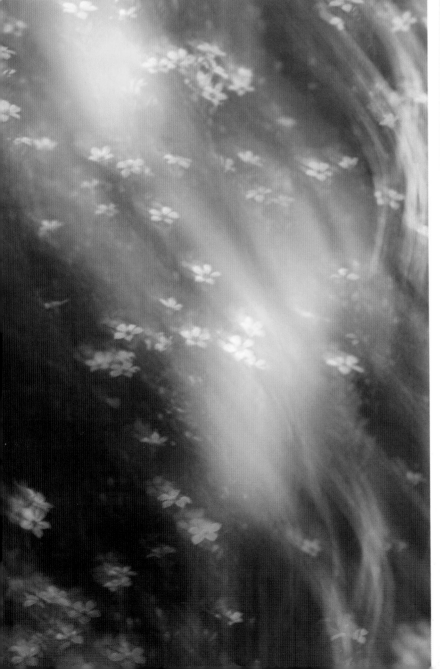

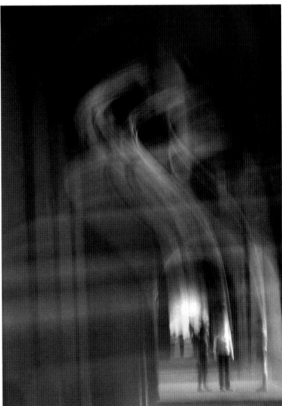

Top—Swiping is a great technique for making floral paintings, and it's a great tool for creative expression. **Bottom left**—Time is an amazing thing for a painter of light. With enough of it, he can literally pull color and shapes from one part of the world to another. To create this image, I used a long exposure (¹/₂ second) to "cook in" the details of the flowers and allow for a quick camera movement to the left so I could include the color and the light that was there. While I moved the camera, I adjusted the focus to blur the scene, allowing only the colors and shapes to come through. **Bottom right**—Slow, methodical movement with your camera will produce more than just an average blur. As you pull and push the colors about, you'll create virtual paintbrush strokes. It's an awesome feeling.

you were making two exposures happen—one in which the image is in focus and one in which you are panning.

You'll run into problems if you are swiping too hard, too far, or not enough. Keep changing things until you can get the image you're after. If you still can't get the technique to work, try this simple (yet amazing) swiping exercise: Find a good, moody punch. Locate a flower, twig, or branch lit with really bright light surrounded by very harsh shadows. Try to swipe the flower from one end of the image frame to the other, and look closely at the scene in your viewfinder. Practice moving the camera so that your subject moves from one end of the frame to the other.

Some students find it easier to simply close their eyes throughout the process and visualize the flower moving. In their mind's eye, they see it crossing the screen, and they simply stop moving when it reaches its mark. With enough practice, this is easily accomplished. Once you've got the technique down, vary your approach. Let the camera "stall out" at the beginning or end of the exposure. Hold it for a bit, and then start the swipe. You'll notice that the stalled-out area will be a bit more in focus than the rest of the image. With enough practice, you should be able to stall out several times during a long exposure, giving your image several points of beautiful focus.

THE FLUTTER

The flutter technique is one of our personal favorites. It brings the whole painting with a lens idea into crisp focus, while at the same time exploiting the use of extreme blur.

Painters often use two classic techniques, pointillism and divisionism, when creating expressionistic forms of art (abstracts). Pointillism and divisionism are similar in style in that both require many graphic elements to make one whole message. Pointillism uses thousands of points of color, placed into specific patterns, to make an image. When an individual looks at the image from a distance, the individual image elements merge to create one flowing message. Only the most skilled artisans use this technique today. Divisionism

■ Painting on bulb is the hardest technique described in this book. It will take an extraordinary amount of time and effort to master. Painting on bulb requires that you develop a feel for the light that surrounds you. Don't expect serious results until you have shot hundreds upon hundreds of bad photos. Take your time, and learn as you progress. Don't give up on the process, the artist in you needs this technique.

Right—If you look closely at this image, you can see how the flutter created multiple versions of the same image and layered them atop one another. The eye, though, sees these colors and shapes and puts them together in its own way, which means that your viewers' reactions will vary. Some will like it, some won't. And that's the true test of the artist. Can you create something that you know others may not like? A photographer strives for acceptance, an artist wants to be heard.

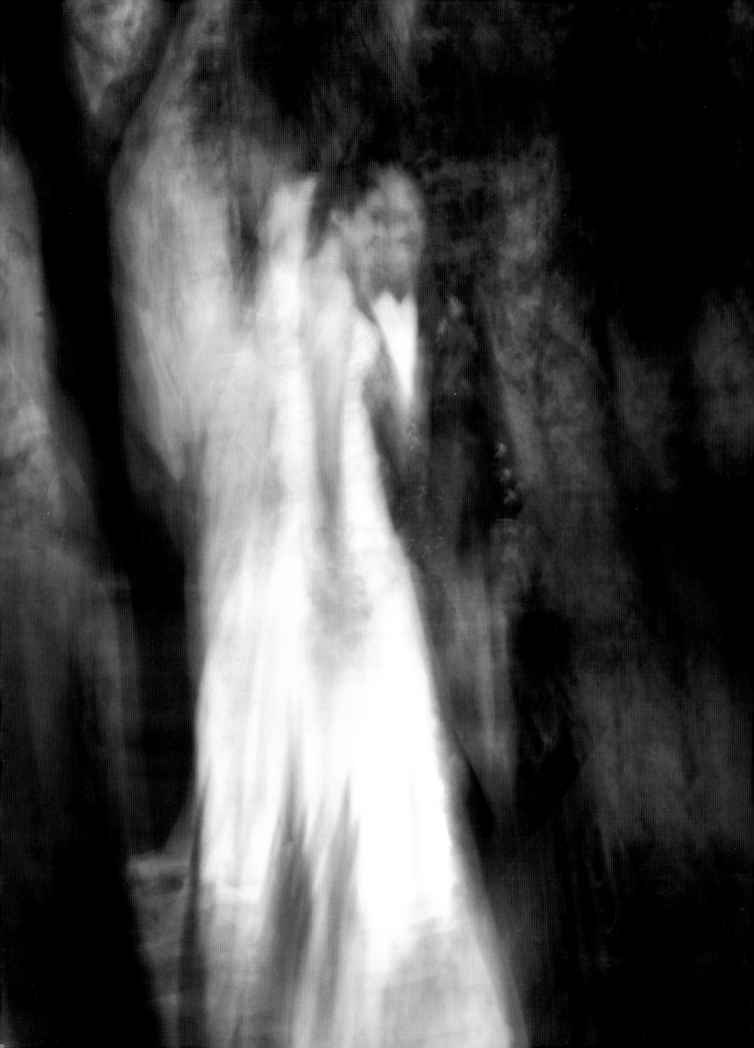

Facing page—Your success with this technique will lie in your ability to visualize the options that using the approach offers. Start simple. Visualize the possibilities that are available to you, and "flutter" away. **Above**—This is truly painting with a lens. Imagine moving your camera when you shoot, creating paint strokes of color and tone. You can't get any more expressive than this!

■ The flutter technique is a bit "out there," so be ready for heads to turn when you begin practicing this technique. As always, your eventual success lies in your willingness to learn from your mistakes, so go ahead and make lots.

is similar to pointillism, but it mainly uses larger (more blocked) areas of color to accomplish the same thing. Photographers can create a similar effect, in-camera, by using the flutter technique.

Begin with your camera set on bulb. Adjust the white balance, contrast, and saturation in camera to establish mood in your image. You must use a tiny aperture, neutral density filters, cross polarize, or use some combination of the above to ensure a very long exposure. There is no exact exposure time that works best. Each artist is unique in how he accomplishes this technique. We have found, however, that a good flutter usually lasts a minimum of one to two minutes.

Since our exposure is very long, it will take an enormous amount of light to work-in the details of the scene. If we can move the camera back and forth from one position to another—quickly and hundreds of times—the "flutter" will allow us to re-create the pointillism/divisionism painting techniques.

How to Do It. As we've mentioned, the flutter requires at least a minute-long exposure. It also requires a controlled movement to occur during the

exposure—a shake of sorts. This shake needs to be repeated, over and over again, so that you move groups of color and focus over one another in a highly controlled manner. One way to accomplish this movement is to create a muscle spasm in your right or left arm. The only problem is that this spasm has to last throughout the entire exposure. If you haven't guessed by now, this can be uncomfortable.

Of course, you can forego the muscle spasm and choose, instead, to simply shake the camera forward and back. Sadly though, from our experience, this doesn't work as well. The technique truly does require precise movements, back and forth over the same areas. Simply moving or shaking the camera doesn't offer that. The muscle spasm approach (yeah, it's weird) works great. By straining your muscle to its extreme, the resulting involuntary spasm offers nearly the same movement throughout the length of the spasm. It works simply because it has no choice. You don't have to think about it, you just need to do it.

Be forewarned: creating a muscle spasm can wear your shooting arm out. Also, we promise that you will get some very odd looks from passersby or friends when you start painting like this, but over time you'll get used to the attention and simply brush it aside. You are, after all, not taking pictures with your camera—you're painting with your lens. And the last time we checked, when painting, you have to move your brush.

■ By placing the colors/contrasts on top of each other in this aggressive yet highly artistic way, we can create wildly fantastic, artful images in less than three minutes flat and all in-camera. Of course, getting the best-possible results will require a lot of practice.

Facing page—Hand-holding the camera and shaking it for several seconds would seem a silly thing to do, but when you consider what you can create, it's not so silly anymore. An in-camera flutter was combined with a simple multiple exposure was used to create the image at the top of the page. This combination of painting techniques allows the most amazing image to happen, right in your camera. We also used the flutter technique to give the "Painted Ladies" of San Francisco a new paint job. **Left**—We all know what the typical Hawaiian beach scene looks like, but what about a painted one? Here, the flutter technique was used once again to create a more artistic interpretation. **Right**—A minute-long flutter created a very dramatic representation of a San Francisco wharf. Note that even though the exposure time was a full minute, the words on the building can still be read. This is probably the most amazing thing about the flutter. If you can control it well enough, the detail you can capture while hand-holding the camera and shaking it for a full minute will amaze you.

■ This whole book has been a primer, an introduction to the techniques an artist with a camera can use. Yet, in the grand scheme of things, what is it that really makes you an artist? Is it the techniques you know, or the desire you have to use them?

WHAT DO YOU WANT TO ACCOMPLISH?

In this book, we've described a variety of techniques for creating images that look more like paintings than photographs. Mastering these skills requires tenacity and perseverance and, for many, success is just right around the corner. However, these are just techniques, nothing more than paintbrushes to the artist. Without a burning need to use them, they sit useless. Just because you can rip an image and pan does not mean you're an artist. You still need a reason to use them and a method for making it happen.

THE PATH

Where do you start when all you have are amazing options? Our suggestion is pretty simple: start at the beginning.

At first, simply learn and work to master the basic techniques found in the beginning of this book. Work your way through slowly; don't skip ahead,

Facing page—It's all in the approach. Even though the tower would have made for an interesting subject, it wasn't enough just to shoot a picture of it. In this image I looked for something different and found it in the reflection on the ground. Give up the simple pursuit of pretty pictures and focus instead on who you are as a person. Give the artist in you a chance. Push your vision and your camera. **Below**— This painted image of a few flamingos in no way resembles what the scene looked like to the eye, yet it clearly expresses how the artist felt about the scene. Photography is not just about weddings, portraits, and poses—it can be about heart, meaning, and expression if you let it. The flutter technique described in chapter 6 was employed to create an ethereal appearance in the image.

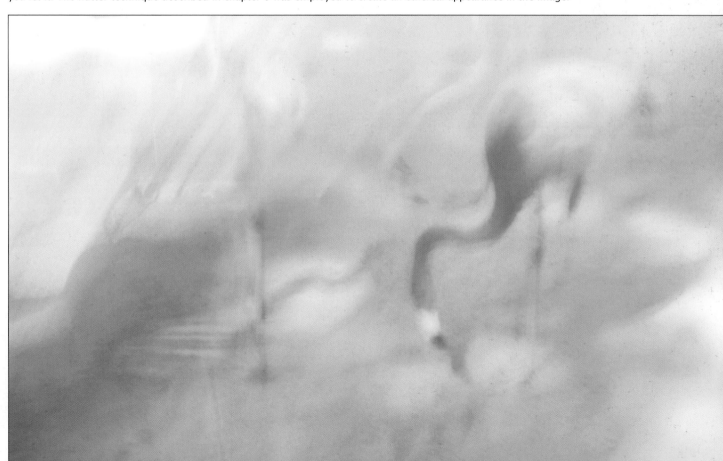

don't miss out. Start by dialing-in your own light, creating your own mood. Make a black background, then flip it around and make a white background. Teach yourself to dial-in a feeling. Punch or rip an image. Change that white balance, adjust the contrast, and play with the saturation. Learn how to focus on depth of field instead of just subjects. Use that depth of field preview button. Be a great manual photographer first, and then let the artist break free. Master slow shutter techniques such as the pan, the spin, and the zoom. Build a firm foundation and create something meaningful. Challenge yourself, and you'll be bound to grow.

From there, move on to tiering your messages. Stretch your imagination farther by seeing more than just one thing at a time. Look at all of the pieces of the graphic puzzle and do something spectacular with them. Finally, learn to paint with light, to move that camera while shooting. Take the risks required to express yourself with your camera.

Once you've mastered all of the techniques we've presented, think about what it is you're going to say with them. Determine which approach is best suited for creating each image. Owning an impressive set of paints doesn't make an artist an excellent painter. Likewise, having a repertoire of great techniques does not make you a talented artist with a camera. True artistry lies in purpose, and that requires a very specific approach.

THE FOUR APPROACHES

There are only four approaches a photographer (or artist) can take when creating an image: expected, educated, expressive, and evasive. This makes things quite simple. If you go in with a plan, things will work out better (they always do). When you have a result in mind, you can determine which techniques will help you create the piece you envision.

The Expected Approach. A camera can record. That's the minimum of what it offers. We can point it at something and shoot. We can keep the camera in auto mode and hope for the best. This is what photography is to many people—and there is nothing wrong with it. Many people don't want to think about their exposure. They don't want to worry about dialing-in a specific white balance, contrast level, or saturation setting. They want to take a simple photograph of what's in front of them. The camera can do that, no problem.

The Educated Approach. This is the approach most photographers want to take. This is when you take the next step and attempt to control your camera and your image. You purposefully use something you've learned, some technique you've mastered, to create an image rather than simply take a photograph. You think and strategize, you use something you know to make something happen. This approach is different for everyone; it really depends on your level of experience. For some, it may prove challenging to simply

■ An artist must look inside himself for the answers to his creative and artistic questions. His images should reflect this desire. They should not be average or normal. He should use techniques unheard of and approaches unseen to create his art. In order to produce a truly artistic and successful image, though, the artist must envision his goal. How can you make the best-possible use of a technique you have at your disposal if you don't know why you need it in the first place?

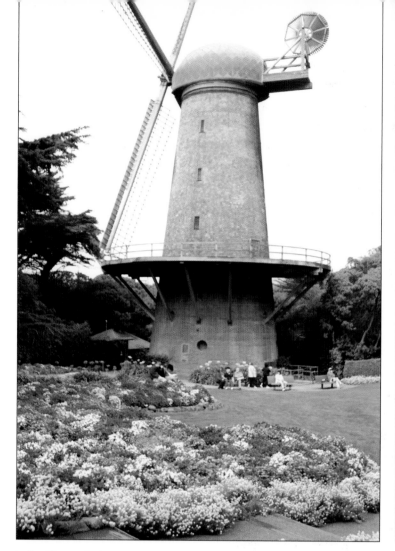
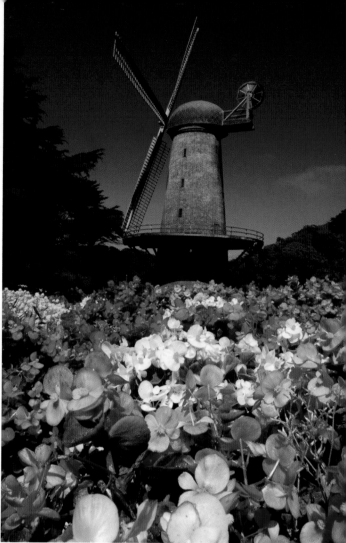

Left—The goal of the expected approach is to simply document a subject or scene, to record life as we see it. These images (such as the one above) are usually shot from the height of the photographer. Little thought has gone into the composition; no real choices were made as to depth of field or perspective. It is simply point-and-shoot photography. **Right**—Shooting in manual mode, a photographer must push himself to create an image with meaning. He uses his knowledge of composition, white balance, contrast, and saturation. He employs a smaller aperture (as in the above photo) to increase his depth of field. He drops down to the ground to better tell the story. An educated approach will yield more appealing photographs.

shoot in manual mode, while others may want to explore the meaning of composition, the use of their polarizer filter, or even depth of field.

The Expressive Approach. The expressive approach is the most selfish of the approaches. It allows the artist to fly free. A photographer who takes this approach is simply concerned with sharing an idea, a thought, or a feeling through his message. It is more a reflection of the artist than anything else. Many express themselves by using the techniques mentioned in this book to create abstract images, though an image need not be abstract to be expressive. If the intent for the image comes from the heart, it's expressive.

The Evasive Approach. This is where things become a lot of fun. Taking the evasive approach simply means that you know what your audience wants to see, yet you do something else instead. You purposefully hide the real message or true intent of your image. While this can be a very rewarding

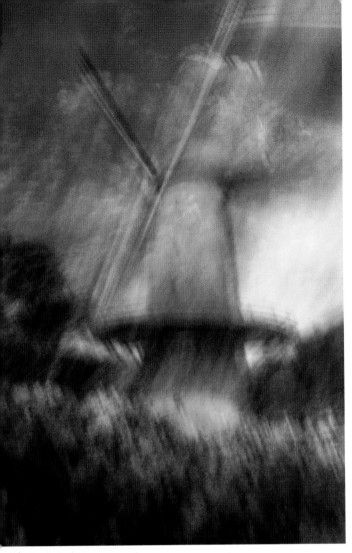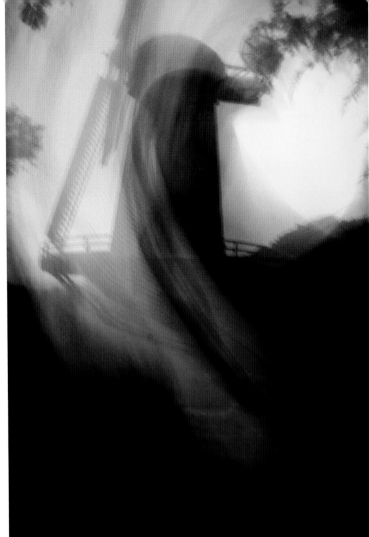

Left—For the artist, it's not just about what's in front of him, it's about how that something could appear. It's about sharing with the world a vision that is as unique as the artist himself. To that end, he simply lets go of societal preconceptions and focuses instead on feeling, meaning, and passion. In this image, a simple flutter technique was used. The image better represents the artist's feelings than a more documentary image would. It's more like a painting than a photograph. **Right**—The fun happens when you begin playing. Yes, you know what the viewer wants to see, so you give them a little taste, but you put enough of your spirit and ingenuity into the image to make it yours.

approach, it's also the most dangerous one. By intentionally hiding meaning, you run the risk of boring your viewer or, worse yet, upsetting or angering them. But then again, if that's your message—this is a great way of getting it across.

BEING "IN FOCUS"

An artist with a camera is in focus. He creates a unique message, chooses an approach, knows what he wants to say, and understands how to do it. He tells a story and shares with the world his vision of what's in front of him. He communicates this difference as boldly and loudly as possible, for it's in this difference that immortality sings. For him, the camera offers a chance to explore his own thoughts and share the results, a lasting memory of the man and his vision, not just of the world that surrounded him.

Ask yourself a question: If someone were to look at your images, would they know you shot them? Is there something special, something that speaks of your vision, your thoughts, or is it just a picture of what was in front of you, lit the way everyone else thinks it should be lit? An artist with a camera is in control of mood, perspective, and depth of field. He uses composition and design. He plays with, tweaks, and manipulates human biases. He explores the random juxtaposition of graphic elements, the ordered placement of things and ideas, and even, on occasion, challenges his own expectations and techniques.

Below—It's not just about how something appears. It's about how it feels to you. As an artist with a camera, it's your responsibility to show the world not just where you were but how you felt as well. These painting techniques (such as the simple rip illustrated in this image) can allow that artist inside of you to be free. Think before you take that next picture. Concentrate equally on the image and on your emotions. Tie them together in such a way as to truly share with the world who you are as an artist.

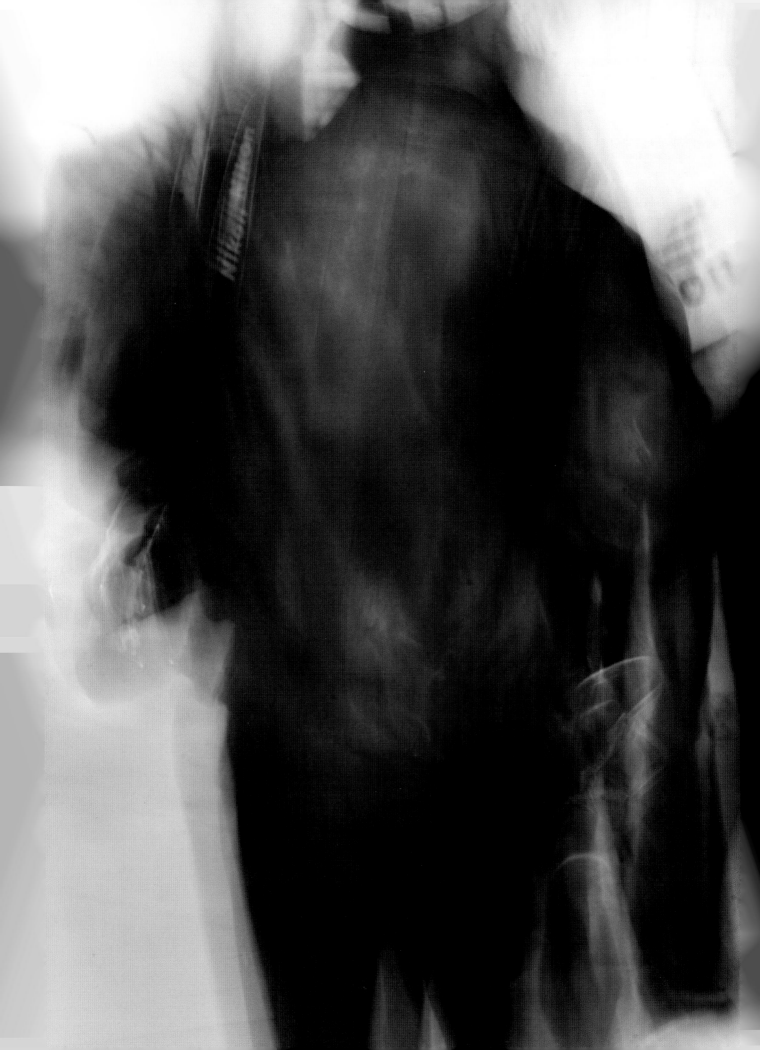

Facing page—There may be times in your life when average just isn't good enough. There may be times when something inside of you screams to be creative, to push society, to do something different. There may be times when the art in life has to come out. When that happens, your camera is there. Break free of the shackles of complacency and be the artist you know you can be. Flutter, swipe, pan, zoom, or tier if you want to. The choice is yours, and it always has been.

How can a photographer do this with his camera set to auto? Automatic exposure, automatic contrast, automatic white balance, automatic saturation, and even automatic focus are designed to give the photographer an average image—one that doesn't challenge society's expectations, one that falls in line with preconceptions, one that looks good to everyone. It produces a normal picture. An artist doesn't want "normal." "Average" is not something to aspire to.

An artist's voice and vision is unique, it's special. How can a camera designed to produce an average image ever give anything but that? Exposure, saturation, contrast, white balance, hue, and focus are important! These are options that can't be thrown away as irrelevant. As an artist, you need all these tools. So what if it takes you a while to figure it all out? Who cares if you don't get great photos right away? Artists need to be unique. They want to take pride in what they do. A machine used in auto mode simply can't give you that.

The question is, are you willing to sacrifice your time and cope with frustration and failure? Can you find the strength to abandon the quest to produce something that is common and normal, choosing, instead, to pursue your own voice and vision? Will you take the challenge and push beyond what you are now, or do you just want to continue to take pretty pictures? Do you want to be in focus, or do you just want in-focus pictures?

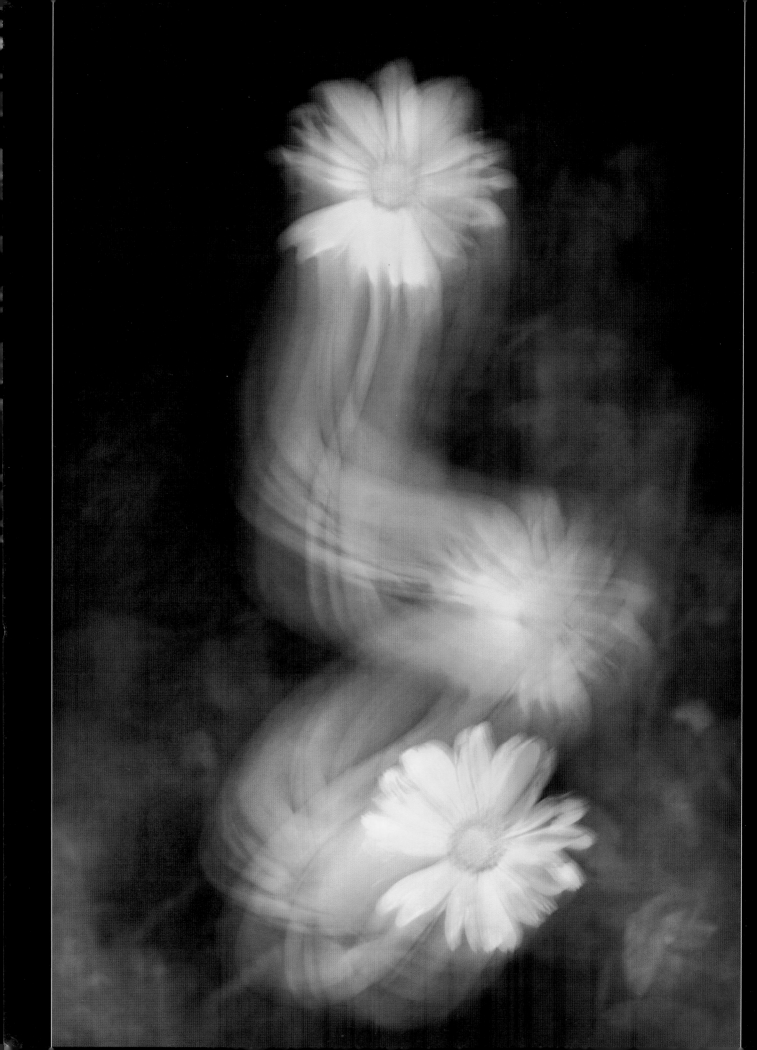

OTHER BOOKS FROM

Amherst Media®

Off-Camera Flash

CREATIVE TECHNIQUES FOR DIGITAL PHOTOGRAPHY

Rod and Robin Deutschmann

Break free from the shackles of natural light and push the limits of design with these off-camera flash techniques. Covers portraits, nature photography, and more. *$34.95 list, 8.5x11, 128p, 269 color images, 41 diagrams, index, order no. 1913.*

Multiple Flash Photography

OFF-CAMERA FLASH TECHNIQUES FOR DIGITAL PHOTOGRAPHERS

Rod and Robin Deutschmann

Use two, three, and four off-camera flash units and modifiers to create photos that break creative boundaries. *$34.95 list, 8.5x11, 128p, 180 color images, 30 diagrams, index, order no. 1923.*

Just One Flash

A PRACTICAL APPROACH TO LIGHTING FOR DIGITAL PHOTOGRAPHY

Rod and Robin Deutschmann

Get down to the basics and create striking images with just one flash. *$34.95 list, 8.5x11, 128p, 180 color images, 30 diagrams, index, order no. 1929.*

Flash Techniques for Macro and Close-up Photography

Rod and Robin Deutschmann

Master the technical skill-set you need to create beautifully lit images that transcend our daily vision of the world. *$34.95 list, 8.5x11, 128p, 300 color images, index, order no. 1938.*

JEFF SMITH'S

Posing Techniques for Location Portrait Photography

Use architectural and natural elements to support the pose, maximize the flow of the session, and create refined, artful poses for individual subjects and groups—indoors or out. *$34.95 list, 8.5x11, 128p, 150 color photos, index, order no. 1851.*

Master Lighting Guide

FOR WEDDING PHOTOGRAPHERS

Bill Hurter

Capture perfect lighting quickly and easily at the ceremony and reception. Includes tips from the pros for lighting individuals, couples, and groups. *$34.95 list, 8.5x11, 128p, 200 color photos, index, order no. 1852.*

Posing Techniques for Photographing Model Portfolios

Billy Pegram

Learn to evaluate your model and create flattering poses for fashion photos, catalog and editorial images, and more. *$34.95 list, 8.5x11, 128p, 200 color images, index, order no. 1848.*

The Best of Portrait Photography, 2nd Ed.

Bill Hurter

View outstanding images from top pros and learn how they create their masterful classic and contemporary portraits. *$34.95 list, 8.5x11, 128p, 180 color photos, index, order no. 1854.*

The Art of Pregnancy Photography

Jennifer George

Learn the essential posing, lighting, composition, business, and marketing skills you need to create stunning pregnancy portraits your clientele can't do without! *$34.95 list, 8.5x11, 128p, 150 color photos, index, order no. 1855.*

Big Bucks Selling Your Photography, 4th Ed.

Cliff Hollenbeck

Build a new business or revitalize an existing one with the comprehensive tips in this popular book. Includes twenty sample forms. *$34.95 list, 8.5x11, 144p, resources, business forms, order no. 1856.*

Illustrated Dictionary of Photography

Barbara A. Lynch-Johnt & Michelle Perkins

Gain insight into camera and lighting equipment, accessories, technological advances, film and historic processes, famous photographers, artistic movements, and more with the concise descriptions in this illustrated book. *$39.95 list, 8.5x11, 144p, 150 color images, order no. 1857.*

Professional Portrait Photography

TECHNIQUES AND IMAGES FROM MASTER PHOTOGRAPHERS

Lou Jacobs Jr.

Veteran author and photographer Lou Jacobs Jr. interviews ten top portrait pros, sharing their secrets for success. *$34.95 list, 8.5x11, 128p, 150 color photos, index, order no. 2003.*

Existing Light

TECHNIQUES FOR WEDDING AND PORTRAIT PHOTOGRAPHY

Bill Hurter

Learn to work with window light, make the most of outdoor light, and use fluorescent and incandescent light to best effect. *$34.95 list, 8.5x11, 128p, 150 color photos, index, order no. 1858.*

THE SANDY PUC' GUIDE TO

Children's Portrait Photography

Learn how Puc' handles every client interaction and session for priceless portraits, the ultimate client experience, and maximum profits. *$34.95 list, 8.5x11, 128p, 180 color images, index, order no. 1859.*

Minimalist Lighting

PROFESSIONAL TECHNIQUES FOR LOCATION PHOTOGRAPHY

Kirk Tuck

Use battery-operated flash units and lightweight accessories to get the top-quality results you want *$34.95 list, 8.5x11, 128p, 175 color images and diagrams, index, order no. 1860.*

FILM & DIGITAL TECHNIQUES FOR

Zone System Photography

Dr. Glenn Rand

A systematic approach to perfect exposure, developing or digitally processing your work, and printing images that suit your creative vision. *$34.95 list, 8.5x11, 128p, 125 b&w and color images, index, order no. 1861.*

THE KATHLEEN HAWKINS GUIDE TO

Sales and Marketing for Professional Photographers

Create a brand identity that lures clients to your studio, then wows them with great customer service and powerful images. *$34.95 list, 8.5x11, 128p, 175 color images, index, order no. 1862.*

LIGHTING TECHNIQUES FOR

Middle Key Portrait Photography

Norman Phillips

Phillips shows you how to orchestrate every aspect of a middle key shoot for cohesive, uncluttered, flattering results. $34.95 list, 8.5x11, 128p, 175 color images/*diagrams*, index, order no. 1863.

Simple Lighting Techniques

FOR PORTRAIT PHOTOGRAPHERS

Bill Hurter

Make complicated lighting setups a thing of the past. In this book, you'll learn how to streamline your lighting for more efficient shoots and more natural-looking portraits. *$34.95 list, 8.5x11, 128p, 175 color images, index, order no. 1864.*

PHOTOGRAPHER'S GUIDE TO

Wedding Album Design and Sales, 2nd Ed.

Bob Coates

Learn how industry leaders design, assemble, and market their albums with the insights and advice in this popular book. *$34.95 list, 8.5x11, 128p, 175 full-color images, index, order no. 1865.*

Lighting for Photography

TECHNIQUES FOR STUDIO AND LOCATION SHOOTS

Dr. Glenn Rand

Gain the technical knowledge of natural and artificial light you need to take control of every scene you encounter—and produce incredible photographs. $34.95 list, 8.5x11, 128p, 150 color images/diagrams, index, order no. 1866.

Sculpting with Light

Allison Earnest

Learn how to design the lighting effect that will best flatter your subject. Studio and location lighting setups are covered in detail with an assortment of helpful variations provided for each shot. *$34.95 list, 8.5x11, 128p, 175 color images, diagrams, index, order no. 1867.*

Step-by-Step Wedding Photography

Damon Tucci

Deliver the images that your clients demand with the tips in this essential book. Tucci shows you how to become more creative, more efficient, and more successful. *$34.95 list, 8.5x11, 128p, 175 color images, index, order no. 1868.*

Professional Wedding Photography

Lou Jacobs Jr.

Jacobs explores techniques and images from over a dozen top professional wedding photographers in this revealing book, taking you behind the scenes and into the minds of the masters. $34.95 list, 8.5x11, 128p, 175 color images, index, order no. 2004.

The Art of Children's Portrait Photography

Tamara Lackey

Create images that are focused on emotion, relationships, and storytelling. Lackey shows you how to engage children, conduct fun sessions, and deliver timeless images. *$34.95 list, 8.5x11, 128p, 240 color images, index, order no. 1870.*

Event Photography Handbook

W. Folsom and J. Goodridge

Learn how to win clients and create outstanding images of award ceremonies, grand openings, political and corporate functions, and other special occasions. *$34.95 list, 8.5x11, 128p, 150 color images, index, order no. 1871.*

50 Lighting Setups for Portrait Photographers
Steven H. Begleiter

Filled with unique portraits and lighting diagrams, plus the "recipe" for creating each one, this book is an indispensible resource *$34.95 list, 8.5x11, 128p, 150 color images and diagrams, index, order no. 1872.*

Digital Photography Boot Camp, 2nd Ed.
Kevin Kubota

Based on Kevin Kubota's sell-out workshop series and fully updated with techniques for Adobe Photoshop and Lightroom. A down-and-dirty course for professionals! *$34.95 list, 8.5x11, 128p, 220 color images, index, order no. 1873.*

Lighting and Photographing Transparent and Translucent Surfaces
Dr. Glenn Rand

Learn to photograph glass, water, and other tricky surfaces in the studio or on location. *$34.95 list, 8.5x11, 128p, 125 color images, diagrams, index, order no. 1874.*

100 Techniques for Professional Wedding Photographers
Bill Hurter

Top photographers provide tips for becoming a better shooter. *$34.95 list, 8.5x11, 128p, 180 color images and diagrams, index, order no. 1875.*

Butterfly Photographer's Handbook
William B. Folsom

Learn how to locate butterflies, approach without disturbing them, and capture spectacular, detailed images. *$34.95 list, 8.5x11, 128p, 175 color images, index, order no. 1877.*

DOUG BOX'S GUIDE TO
Posing for Portrait Photographers
Based on Doug Box's popular workshops for professional photographers, this visually intensive book allows you to quickly master the skills needed to pose men, women, children, and groups. *$34.95 list, 8.5x11, 128p, 200 color images, index, order no. 1878.*

500 Poses for Photographing Women
Michelle Perkins

A vast assortment of inspiring images, from head-and-shoulders to full-length portraits, and classic to contemporary styles—perfect for when you need a little shot of inspiration to create a new pose. *$34.95 list, 8.5x11, 128p, 500 color images, order no. 1879.*

Power Marketing, Selling, and Pricing a Business Guide for Wedding and Portrait Photographers, 2nd ed.
Mitche Graf

Master the skills you need to take control of your business, boost your bottom line, and build the life you want. *$34.95 list, 8.5x11, 144p, 90 color images, index, order no. 1876.*

Minimalist Lighting
PROFESSIONAL TECHNIQUES FOR STUDIO PHOTOGRAPHY
Kirk Tuck

Learn how technological advances have made it easy and inexpensive to set up your own studio. *$34.95 list, 8.5x11, 128p, 190 color images and diagrams, index, order no. 1880.*

Master Posing Guide for Wedding Photographers
Bill Hurter

Learn to create images that make your clients look their very best while still reflecting the spontaneity and joy of the event. *$34.95 list, 8.5x11, 128p, 180 color images and diagrams, index, order no. 1881.*

ELLIE VAYO'S GUIDE TO
Boudoir Photography

Learn how to create flattering, sensual images that women will love as gifts or keepsakes. Covers everything you need to know—from getting clients in the door, to running a succesful session, to making a big sale. *$34.95 list, 8.5x11, 128p, 180 color images, index, order no. 1882.*

MASTER GUIDE FOR
Photographing High School Seniors
Dave, Jean, and J. D. Wacker

Learn how to stay at the top of the ever-changing senior portrait market with these techniques for success. *$34.95 list, 8.5x11, 128p, 270 color images, index, order no. 1883.*

Photographing Jewish Weddings
Stan Turkel

Learn the key elements of the Jewish wedding ceremony, terms you may encounter, and how to plan your schedule for flawless coverage of the event. *$39.95 list, 8.5x11, 128p, 170 color images, index, order no. 1884.*

Available Light
PHOTOGRAPHIC TECHNIQUES
FOR USING EXISTING LIGHT SOURCES
Don Marr

Find great light, modify not-so-great light, and harness the beauty of some unusual light sources in this step-by-step book. *$34.95 list, 8.5x11, 128p, 135 color images, index, order no. 1885.*

JEFF SMITH'S GUIDE TO

Head and Shoulders Portrait Photography

Make head and shoulders portraits a more creative and lucrative part of your business—whether in the studio or on location. *$34.95 list, 8.5x11, 128p, 200 color images, index, order no. 1886.*

THE PHOTOGRAPHER'S GUIDE TO MAKING MONEY

150 ideas for Cutting Costs and Boosting Profits

Karen Dórame

Learn how to reduce overhead, improve marketing, and increase your studio's overall profitability. *$34.95 list, 8.5x11, 128p, 200 color images, index, order no. 1887.*

On-Camera Flash

TECHNIQUES FOR DIGITAL WEDDING AND PORTRAIT PHOTOGRAPHY

Neil van Niekerk

Use on-camera flash to create lighting that flatters your subjects—and doesn't slow you down on location shoots. *$34.95 list, 8.5x11, 128p, 190 color images, index, order no. 1888.*

Lighting Techniques for Photographing Model Portfolios

Billy Pegram

Pegram provides start-to-finish analysis of real-life sessions, showing you how to make the right decisions each step of the way. *$34.95 list, 8.5x11, 128p, 150 color images, index, order no. 1889.*

Commercial Photography Handbook

BUSINESS TECHNIQUES FOR PROFESSIONAL DIGITAL PHOTOGRAPHERS

Kirk Tuck

Learn how to identify, market to, and satisfy your target markets—and make important financial decisions to maximize profits. *$34.95 list, 8.5x11, 128p, 110 color images, index, order no. 1890.*

Creative Wedding Album Design

WITH ADOBE® PHOTOSHOP®

Mark Chen

Master the skills you need to design wedding albums that will elevate your studio above the competition. *$34.95 list, 8.5x11, 128p, 225 color images, index, order no. 1891.*

CHRISTOPHER GREY'S

Studio Lighting Techniques for Photography

With these strategies—and some practice—you'll approach your sessions with confidence! *$34.95 list, 8.5x11, 128p, 320 color images, index, order no. 1892.*

JEFF SMITH'S

Senior Portrait Photography Handbook

Improve your images and profitability through better design, market analysis, and business practices. *$34.95 list, 8.5x11, 128p, 170 color images, index, order no. 1896.*

JERRY D'S

Extreme Makeover Techniques

FOR DIGITAL GLAMOUR PHOTOGRAPHY

Bill Hurter

Learn the secrets of creating glamour images that bring out the very best in every woman. *$34.95 list, 8.5x11, 128p, 270 color images, index, order no. 1897.*

Professional Commercial Photography

Lou Jacobs Jr.

Insights from ten top commercial photographers make reading this book like taking ten master classes—without having to leave the comfort of your living room! *$34.95 list, 8.5x11, 128p, 160 color images, index, order no. 2006.*

PROFESSIONAL DIGITAL TECHNIQUES FOR

Photographing Bar and Bat Mitzvahs

Stan Turkel

Learn the important shots to get—from the synagogue, to the party, to family portraits—and the symbolism of each phase of the ceremony and celebration. *$39.95 list, 8.5x11, 128p, 140 color images, index, order no. 1898.*

500 Poses for Photographing Brides

Michelle Perkins

Filled with images by some of the world's best wedding photographers, this book can provide the inspiration you need to spice up your posing or refine your techniques. *$34.95 list, 8.5x11, 128p, 500 color images, index, order no. 1909.*

The Best of Wedding Photojournalism, 2nd Ed.

Bill Hurter

From the pre-wedding preparations to the ceremony and reception, you'll see how professionals identify fleeting moments and capture them in an instant. *$34.95 list, 8.5x11, 128p, 150 color images, index, order no. 1910.*

THE BEGINNER'S GUIDE TO

Underwater Digital Photography

Larry Gates

Written for the "regular guy" photographer, this book shows you how to make smart technical and creative decisions. *$34.95 list, 8.5x11, 128p, 160 color images, index, order no. 1911.*

The Art of Posing
TECHNIQUES FOR DIGITAL PORTRAIT PHOTOGRAPHERS
Lou Jacobs Jr.

Create compelling poses for individuals, couples, and families. Jacobs culls strategies and insights from ten photographers whose styles range from traditional to modern. *$34.95 list, 8.5x11, 128p, 180 color images, index, order no. 2007.*

Photographic Lighting Equipment
Kirk Tuck

Learn to navigate through the sea of available lights, modifiers, and accessories and build the best arsenal for your specific needs. *$34.95 list, 8.5x11, 128p, 350 color images, 20 diagrams, index, order no. 1914.*

Advanced Wedding Photojournalism
Tracy Dorr

Tracy Dorr charts a path to a new creative mind-set, showing you how to get better tuned in to a wedding's events and participants so you're poised to capture outstanding, emotional images. *$34.95 list, 8.5x11, 128p, 200 color images, index, order no. 1915.*

Corrective Lighting, Posing & Retouching
FOR DIGITAL PORTRAIT PHOTOGRAPHERS, 3RD ED.
Jeff Smith

Address your subject's perceived physical flaws in the camera room and in postproduction to boost client confidence and sales. *$34.95 list, 8.5x11, 128p, 180 color images, index, order no. 1916.*

Children's Portrait Photography Handbook, 2nd Ed.
Bill Hurter

Excel at the art of photographing children. Includes unique portrait concepts, strategies for eliciting expressions, gaining cooperation on the set, and more. *$34.95 list, 8.5x11, 128p, 150 color images, index, order no. 1917.*

TUCCI AND USMANI'S
The Business of Photography
Damon Tucci and Rosena Usmani

Take your business from flat to fantastic using the foundational business and marketing strategies detailed in this book. *$34.95 list, 8.5x11, 128p, 180 color images, index, order no. 1919.*

CHRISTOPHER GREY'S
Advanced Lighting Techniques
Learn how to create twenty-five unique portrait lighting effects that other studios can't touch. Grey's popular, stylized effects are easy to replicate with this witty and highly informative guide. *$34.95 list, 8.5x11, 128p, 200 color images, 26 diagrams, index, order no. 1920.*

THE DIGITAL PHOTOGRAPHER'S GUIDE TO
Light Modifiers
SCULPTING WITH LIGHT™
Allison Earnest

Choose and use an array of light modifiers to enhance your studio and location images. *$34.95 list, 8.5x11, 128p, 190 color images, 30 diagrams, index, order no. 1921.*

JOE FARACE'S
Glamour Photography
Farace shows you budget-friendly options for connecting with models, building portfolios, selecting locations and backdrops, and more. *$34.95 list, 8.5x11, 128p, 180 color images, 20 diagrams, index, order no. 1922.*

CHRISTOPHER GREY'S
Lighting Techniques for Beauty and Glamour Photography
Create evocative, detailed shots that emphasize your subject's beauty. Grey presents twenty-six varied approaches to classic, elegant, and edgy lighting. *$34.95 list, 8.5x11, 128p, 170 color images, 30 diagrams, index, order no. 1924.*

Understanding and Controlling Strobe Lighting
John Siskin

Learn how to use a single strobe, synch lights, modify the source, balance lights, perfect exposure, and much more. *$34.95 list, 8.5x11, 128p, 150 color images, 20 diagrams, index, order no. 1927.*

JEFF SMITH'S
Studio Flash Photography
This common-sense approach to strobe lighting shows working photographers how to master solid techniques and tailor their lighting setups to individual subjects. *$34.95 list, 8.5x11, 128p, 150 color images, index, order no. 1928.*

WES KRONINGER'S
Lighting Design Techniques
FOR DIGITAL PHOTOGRAPHERS
Design portrait lighting setups that blur the lines between fashion, editorial, and traditional portrait styles. *$34.95 list, 8.5x11, 128p, 80 color images, 60 diagrams, index, order no. 1930.*

DOUG BOX'S
Flash Photography
ON- AND OFF-CAMERA TECHNIQUES
FOR DIGITAL PHOTOGRAPHERS
Master the use of flash, alone or with light modifiers. Box teaches you how to create perfect portrait, wedding, and event shots, indoors and out. *$34.95 list, 8.5x11, 128p, 345 color images, index, order no. 1931.*

500 Poses for Photographing Men
Michelle Perkins

Overcome the challenges of posing male subjects with this visual sourcebook, showcasing an array of head-and-shoulders, three-quarter, full-length, and seated and standing poses. *$34.95 list, 8.5x11, 128p, 500 color images, order no. 1934.*

Off-Camera Flash
TECHNIQUES FOR DIGITAL PHOTOGRAPHERS
Neil van Niekerk

Learn how to set your camera, which flash settings to employ, and where to position your flash for exceptional results. *$34.95 list, 8.5x11, 128p, 235 color images, index, order no. 1935.*

Wedding Photojournalism
THE BUSINESS OF AESTHETICS
Paul D. Van Hoy II

Learn how to create strong images and implement the powerful business and marketing practices you need to reach your financial goals. *$34.95 list, 8.5x11, 128p, 230 color images, index, order no. 1939.*

THE DIGITAL PHOTOGRAPHER'S GUIDE TO
Natural-Light Family Portraits
Jennifer George

Learn how using natural light and fun, meaningful locations can help you create cherished portraits and bigger sales. *$34.95 list, 8.5x11, 128p, 180 color images, index, order no. 1937.*

BILL HURTER'S
Small Flash Photography
From selecting gear, to placing the small flash units, to ensuring proper flash settings and communication, this book shows you how to take advantage of this new approach to lighting. *$34.95 list, 8.5x11, 128p, 180 color photos and diagrams, index, order no. 1936.*

Studio Lighting Anywhere
THE DIGITAL PHOTOGRAPHER'S GUIDE TO LIGHTING ON LOCATION AND IN SMALL SPACES
Joe Farace

Create precision studio lighting in any location, indoors or out, and achieve total control over your portrait results. *$34.95 list, 8.5x11, 128p, 200 color photos and diagrams, index, order no. 1940.*

Family Photography
THE DIGITAL PHOTOGRAPHER'S GUIDE TO BUILDING A BUSINESS ON RELATIONSHIPS
Christie Mumm

Build client relationships that allow you to capture clients' life-cycle milestones, from births, to high-school pictures, to weddings. *$34.95 list, 8.5x11, 128p, 220 color images, index, order no. 1941.*

Flash and Ambient Lighting for Digital Wedding Photography
Mark Chen

Meet every lighting challenge with these tips for shooting with flash, ambient light, or flash and ambient light together. *$34.95 list, 8.5x11, 128p, 200 color photos and diagrams, index, order no. 1942.*

500 Poses for Photographing Couples
Michelle Perkins

Overcome the challenges of posing couples with this visual sourcebook, showcasing an array of head-and-shoulders, three-quarter, full-length, and seated and standing poses. *$34.95 list, 8.5x11, 128p, 500 color images, order no. 1943.*

Posing for Portrait Photography
A HEAD-TO-TOE GUIDE FOR DIGITAL PHOTOGRAPHERS, 2ND ED.
Jeff Smith

This book will show you how to correct the most common figure problems, design poses that look natural, and craft images clients are sure to love. *$34.95 list, 8.5x11, 128p, 200 color images, index, order no. 1944.*

MORE PHOTO BOOKS ARE AVAILABLE

Amherst Media®
PO BOX 586
BUFFALO, NY 14226 USA

Individuals: If possible, purchase books from an Amherst Media retailer. Contact us for the dealer nearest you, or visit our web site and use our dealer locater. To order direct, visit our web site, or send a check/money order with a note listing the books you want and your shipping address. All major credit cards are also accepted. For domestic and international shipping rates, please visit our web site or contact us at the numbers listed below. New York state residents add 8.75% sales tax.

Dealers, distributors & colleges: Write, call, or fax to place orders. For price information, contact Amherst Media or an Amherst Media sales representative. Net 30 days.

(800) 622-3278 or (716) 874-4450
Fax: (716) 874-4508

*All prices, publication dates, and specifications
are subject to change without notice.
Prices are in U.S. dollars. Payment in U.S. funds only.*

WWW.AMHERSTMEDIA.COM
FOR A COMPLETE CATALOG OF BOOKS AND ADDITIONAL INFORMATION

VERNON AREA PUBLIC LIBRARY
LINCOLNSHIRE, IL 60069